IMAGES
of America

SALIDA
COLORADO

Kay Marnon Danielson

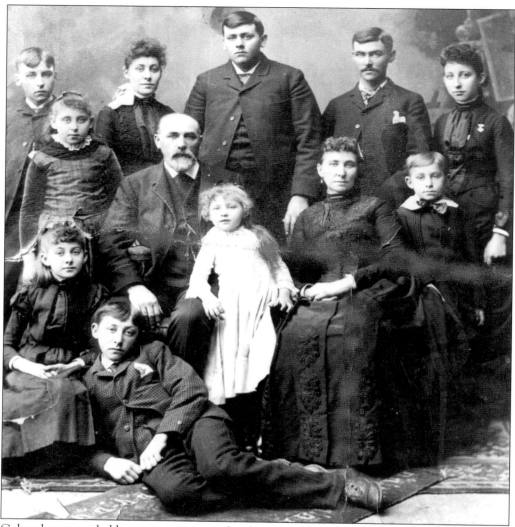

Colorado was settled by many immigrant families. Some had photos taken before leaving their home countries and others celebrated their new circumstances, sending photos to the family they left behind. (Salida Regional Library, Martin Epp)

IMAGES
of America

SALIDA
COLORADO

Kay Marnon Danielson

ARCADIA

Published by Arcadia Publishing,
an imprint of Tempus Publishing, Inc.
3047 N. Lincoln Ave., Suite 410
Chicago, IL 60657

Printed in Great Britain.

Library of Congress Catalog Card Number: Applied for

For all general information contact Arcadia Publishing at:
Telephone 843-853-2070
Fax 843-853-0044
E-Mail sales@arcadiapublishing.com

For customer service and orders:
Toll-Free 1-888-313-2665

Visit us on the internet at http://www.arcadiapublishing.com

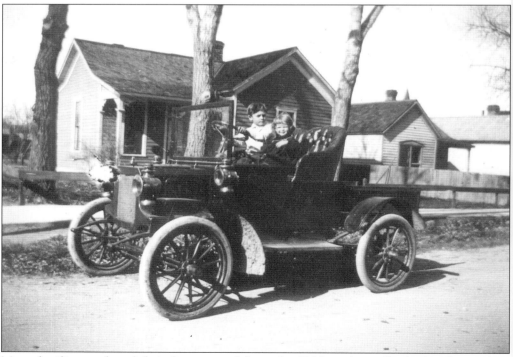

Many families purchased their first automobile in the 1930s and proudly displayed it in their photographs. (Salida Regional Library, Josephine Souhup Kratky)

CONTENTS

ACKNOWLEDGMENTS

First and foremost, my gratitude and thanks to Jack and Sandy Gordon. They introduced me to Salida, and without their generous and patient hospitality, this book would never have been attempted.

Chaffee County has been photographically well-documented for over 100 years. Individuals and organizations kindly opened their photo collections to a stranger and shared their knowledge and love of this special place. Those included:

Judy Micklich, Earle Kittleman—The Salida Museum Association
Jeff Donlan—Salida Regional Library
Robert Rush—Salida Attorney
Charles Medina, Ann Ewing—Salida Ranger District San Isabel National Forests
J.E. Lionelle—President of U.S. Soil, Inc.
Beth Smith—First United Methodist Church
Donna Rhoads—FIBArk
Dr. Wendell Hutchinson—D.V.M., historian

There are also many fine publications on the history of the area and they can be referenced at the Salida Regional Library. Especially helpful to the author were *The Upper Arkansas; A Mountain River Valley* by Virginia McConnell Simmons, *Under the Angel of Shaveno* by George G. Everett and Dr. Wendell F. Hutchinson, *A History of Chaffee County* by June Shaputis and Suzanne Kelley, and *100 Years in the Heart of the Rockies* by Cynthia J. Pasquale.

This book makes no pretense of being a comprehensive history. It is a glimpse into the lives of the people and events that shaped the place once called South Arkansas into today's Salida, Colorado.

INTRODUCTION

Part of the history of the area now known as Salida, Colorado, was created over eons as water, upheavals from the Earth, wind, and other forces of nature formed deposits in the ground. The surface eventually became a beautiful valley bordered by 14,000-foot high mountains that fed a young Arkansas River to supply water, a mild climate, and abundant animal life.

These factors encouraged humans to come—Ute Indians, Spanish, French, and American explorers, Mexican settlers, trappers, traders, farmers, ranchers, tourists, and miners. The eastern part of Colorado was acquired through the 1803 Louisiana Purchase and the rest of the land from the Texas Territory separating from Mexico in 1836. Colorado was named a territory in 1861 and became the 38th state in 1876; Salida incorporated in 1880 with the coming of the railroad.

The community thrived and adjusted as events unfolded. Gold petered out, the silver panic closed many claims, and eventually most of the mining activity came to a halt. In the mid-20th century, the railroads packed up and left. But the community of Salida had planted itself firmly in the ground and looked ahead. Today's economy depends largely on tourism, light industry, and community support businesses.

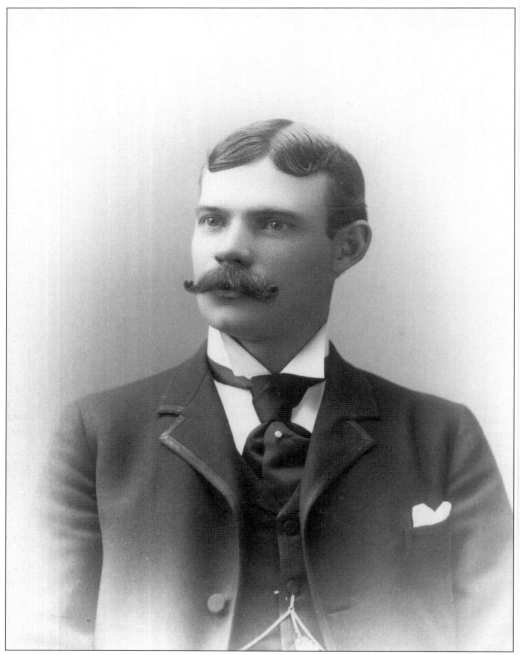

The West was a land of promise and opportunity for many around the turn of the century. This young man might have been a banker, businessman, or simply a wealthy traveler. (Salida Museum Association)

One
AGRICULTURE

*R*anchers and farmers were some of the first settlers in the Salida area. A wide valley between the mountains, the town's mild climate, and available foliage and water supported herds of cattle that provided meat for miners and railroad crews as well as supplying stock for long trail drives to Midwest stockyards. Grains and vegetables grew—oats, wheat, barley, and hay, as well as potatoes, peas, turnips, and lettuce.

The people came and thrived in this valley between the mountains, where wide expanses of prairie awaited settlers. (Dr. Wendell F. Hutchinson)

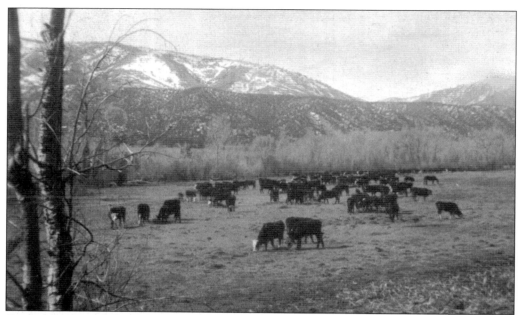

Cattle have grazed this land for over 150 years, and ranching remains a substantial part of the community's commerce today. (Dr. Wendell F. Hutchinson)

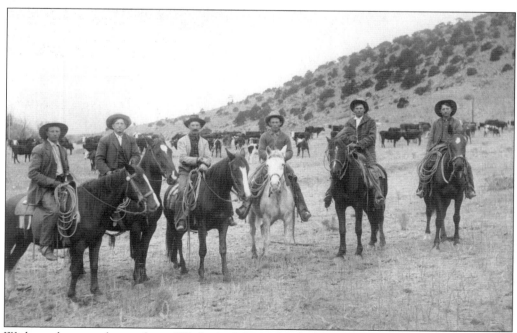

With cattle came the cowboys. While the life was hard—long hours in the saddle, extremes of temperatures, ill-tempered cattle—many chose it above all other occupations. Pictured, from left to right, are Frank Fehling, Jack Cogan, Jim Rich, Bert Swain, Charles Matlock, and Button Copper. (Dr. Wendell F. Hutchinson)

Storing hay outdoors in huge stacks included use of two A frames with a cable between. The cable removed hay from a wagon and built a stack that might be 30 feet high and last all winter. (Dr. Wendell F. Hutchinson)

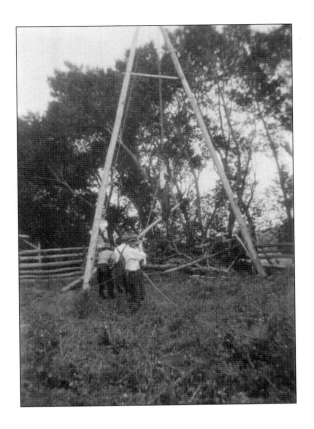

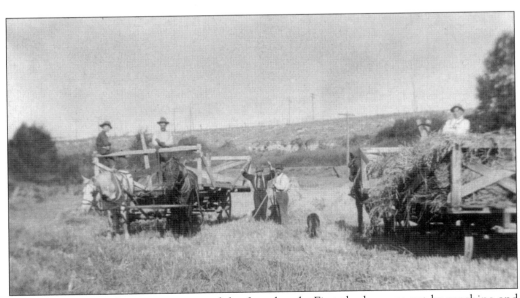

Haying was a big job requiring most of the farm hands. First the hay was cut by machine and then loaded on wagons by pitchfork. (Dr. Wendell F. Hutchinson)

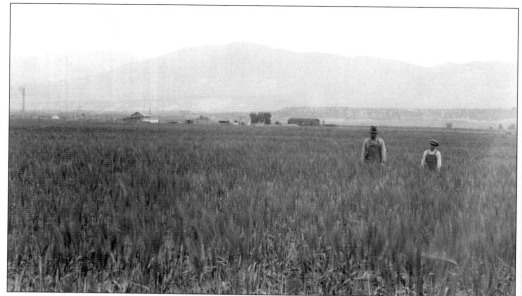

Oats, alfalfa, field peas, vegetables, and bush fruits grew in the valley. This farmer and his son stood proudly in their field of barley. (Salida Museum Association)

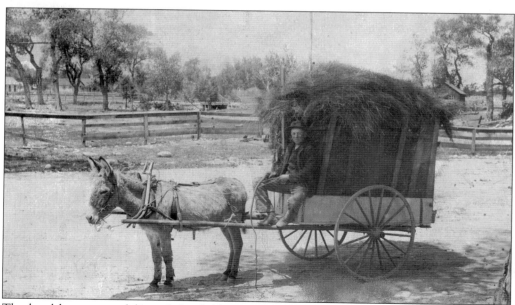

The local hay wagon delivered the fodder to small landholders with a few head of livestock. (Salida Museum Association)

The Hutchinson family came to Colorado shortly after the Civil War and settled in Salida in 1867. Mills Hutchinson was born in the original ranch house that is still standing on Route 50 between Salida and Poncha Springs. His son, Wendell Hutchinson, served the community as a respected veterinarian for over 50 years, specializing in cattle. (Dr. Wendell F. Hutchinson)

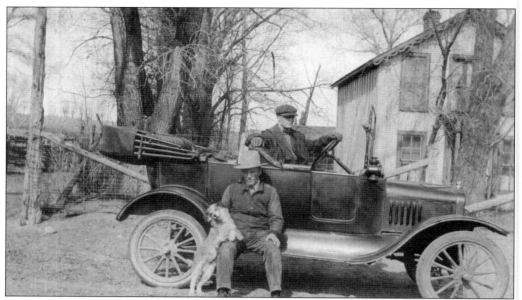

Bailey and Mills Hutchinson pose with the car they purchased in 1919 for some mining stock and $20. In the background are the Hutchinson homestead ranch and buildings that still stand on Route 50 between Salida and Poncha Springs. (Dr. Wendell F. Hutchinson)

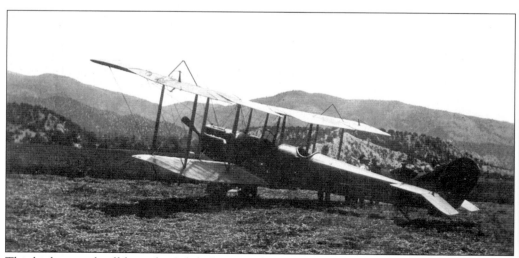

This biplane took off from the Salida fairgrounds and lost power. It landed on the Hutchinson ranch, was repaired, and took to the air again. (Dr. Wendell F. Hutchinson)

Italian families were well-represented in the valley. Like Joe Martellaro, they married, started families, and generations later their descendants still call Salida home. (J.E. Lionelle)

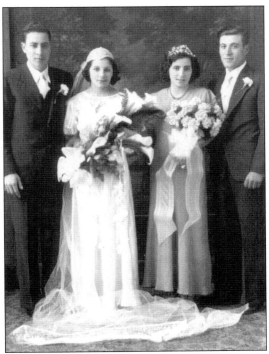

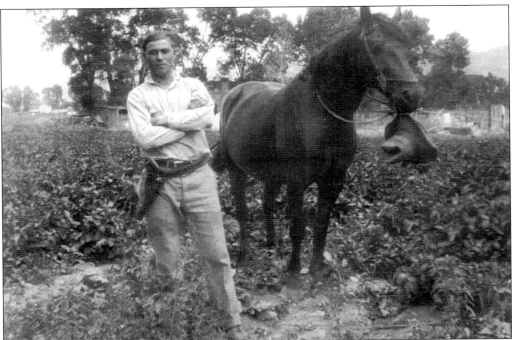

Lettuce proved to be a good crop as early as 1918 when 400 acres were under cultivation. Packed in ice and shipped to market, the vegetable was a viable crop for many years. Joe Martellaro ranched and grew lettuce in the 1940s; his horse Babe often carried his hat for him. (J.E. Lionelle)

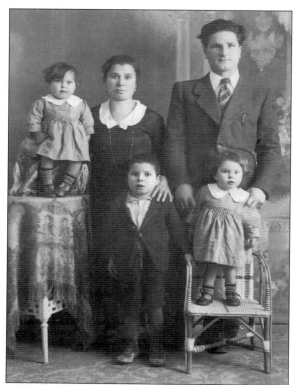

The husband and father of the Guccione family was unavailable for this portrait so his twin brother stood in to have the photo made before leaving Italy in the 1920s. The family immigrated to Salida and began ranching. (J.E. Lionelle)

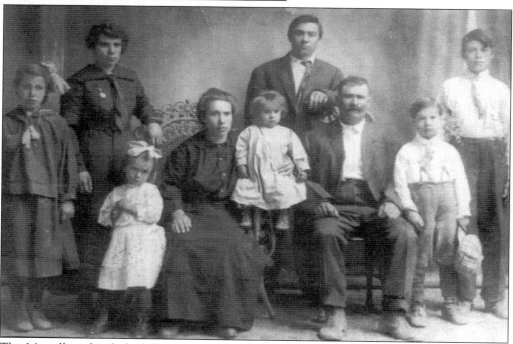

The Martellaro family had this picture made before leaving Italy and heading to America to seek a new life. (J.E. Lionelle)

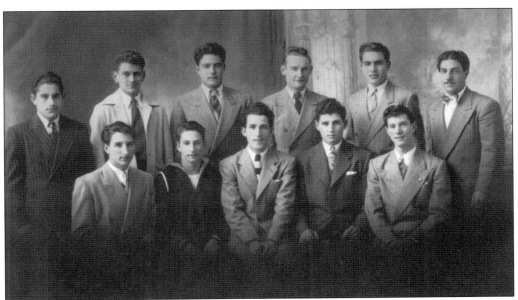

This group of young Italian men gathered for a photograph before some of them went off to World War II. (J.E. Lionelle)

The Salida stockyards were still in use in the late part of the 20th century. Much earlier in its history, the old iron bridge leading to the stockyards was used to hang outlaws. (Salida Museum Association)

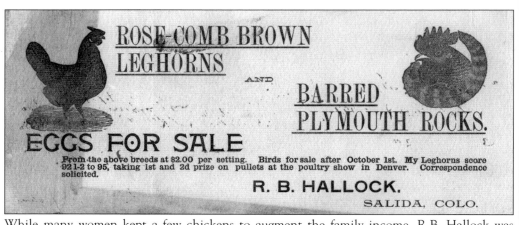

While many women kept a few chickens to augment the family income, R.B. Hallock was involved in the chicken business in a much bigger way. (Salida Museum Association)

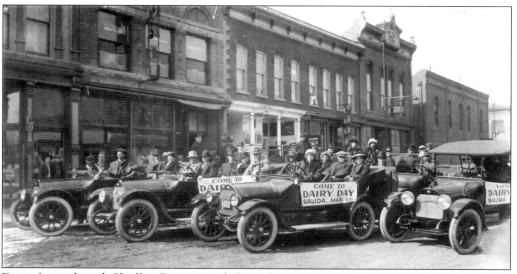

Dairy farms dotted Chaffee County, and those farmers were well represented on this 1930s Dairy Day celebration. (Salida Museum Association)

18

Two

MINING

*I*nland seas, upheavals of earth and swamp, volcanic action, and Arkansas River erosion all contributed to the creation of mineral deposits of gold, silver, lead, zinc, copper, iron, and molybdenum. Tremendous heat and pressure formed semi-precious gemstones, and layers upon layers of sediment left limestone, gypsum, coal, and oil. Those riches lay quietly in the mountains until gold fever struck Colorado in 1858. An onslaught of prospectors arrived and mining began with the placer operations—retrieving glacial or alluvial deposits of gold particles from sand or gravel in streams or riverbeds. Before long, mine shafts were dug deep into the mountains to extract other ores. Railroads were built, smelters erected, and more people came to settle the towns and villages in the area. All that remains of many of those places are a few scattered buildings giving mute testimony to the past.

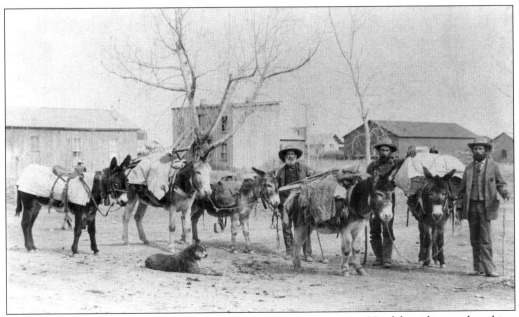

Burros were the all-terrain vehicles of the mountain mining camps. Used for riding and packing 200 pounds of supplies, their sure-footedness and capacity to forage on sparse vegetation made them a favorite for the miners. (Salida Regional Library)

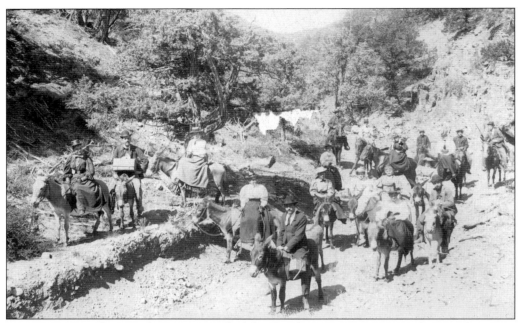

Many miners working in the mountains had families living in town. Around 1890, this group of women (riding sidesaddle) and armed men went into the mountains to visit the mine camps, taking fresh supplies and news of home with them. (Salida Museum Association)

HOWARD E. BURTON,

Assayer and Chemist,

111 EAST FOURTH ST.

JUN 8 1909

Leadville, Colo.,_____190____

Assayed for *Madonna*_____ Result per ton of 2,000 pounds:

MARKS.	GOLD Ounces	SILVER Ounces	LEAD Per Ct.	COPPER per ct. (wet)	IRON Per Ct.	MANG. Per Ct.	SILICA Per Ct.	ZINC Per Ct.	Per Ct.
637-396	23	2	11²		43²	0⁵	6²		
	25	3	11⁴		42⁴	2	6²		
	26	3	11³			25	6²		
	.25	Rp	11²		Rp.				
305-307a	04	4	2⁸		48²	0³	6⁸		
	.05	3⁴	4²		44	2	11.		
	1.045	Rp	Rp		Rp	Rp			

PHONE 165-A

AUSTIN, THE PRINTER

_____ *W. C. Burton* _____ **Assayer.**

The much anticipated assayer's report could make or break a claim holder's future. This 1909 one reported on the Madonna Mine's gold, silver, lead, copper, iron, manganese, silica, and zinc contents. (Salida Museum Association)

20

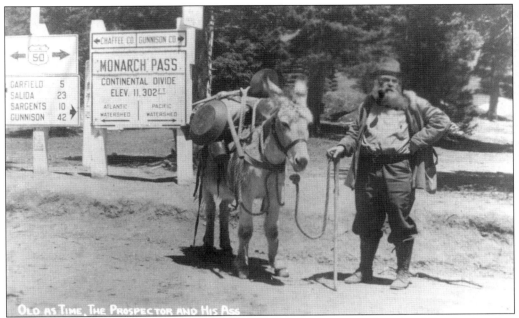

Known as the Hermit of Arborville, Frank Gimlet was reported to be full of tales that romanticized prospecting and the Old West. (Salida Museum Association)

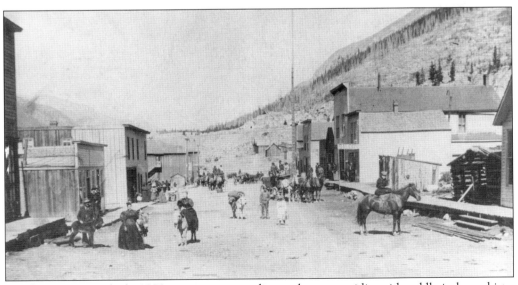

St. Elmo was typical of a 1890s mining town—dirt road, women riding sidesaddle in long skirts, and wooden store buildings that provided trade and transportation supplies to silver and gold miners. (Rush)

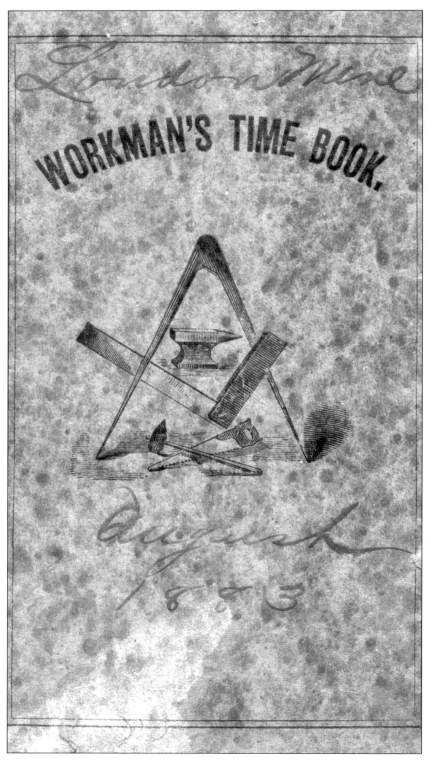

London Mine

WORKMAN'S TIME BOOK.

August
1883

The miners kept a time log of their work for the paymaster. This one is dated 1883 for the London Mine. (Salida Museum Association)

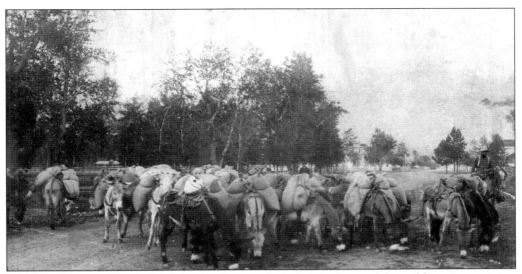

Capable of carrying heavy loads on rough trails, before the advent of the rail lines into mining country burro or horse pack trains were the only way of getting supplies to camps high in the mountains. (Salida Museum Association)

There were few amenities in the town of Monarch around 1885 unless you count the 24-hour saloons and brothels. Established for silver, gold, lead, and zinc mining, the town eventually depended more on the local limestone quarry for sustenance, but even that declined and was deserted. Presently, the site is a Forest Service campground. (Salida Museum Association)

TIME BOOK for the

NAMES.	1	2	3	4	5	6	7	8	9	10	11	12	13	14
McLeod M	/	/	/	/	/	/	/	/	/	/	/	/	/	
" " Angus	/	/	/	/	/	/	/	/	/	/	✗	✗	/	/
" Donald D J	/	/	/	/	/	/	/	/	/	/	/	?	/	
" " J J	/	/	/	/	/	/	/	/	/	/	/	/	/	
" " J & C	/	/	/	/	/	/	/	/	/	/	2/	/	/	
" " Angus	/	/	/	/	/	/	/	/	/	/	/	?	/	
" " Alex														
" Vey James	/	/	/	/	/	/	/	/	½	Sun				
" Gregor Alex	/	/	/	/	/	/	/	/	/	?	/	/		
" Neil John	/	/	/	/	/	/	/	/	/	/	/	/	✗	
" Leary Joseph	/	/	/	/	/	/	/	/	/	½	/	/		
" Eachen M	/	/	/	/	/	/	/	/	/	/	/	/		
" " Archie	/	/	/	/	/	/	/	/	/	?	/	/		
" Pennie Peter	/	/	/	/	/	/	/	/	✗	/	✗			

Ethnic groups often lived and worked together. This 1883 miner's time book lists McLeod, McDonald, McVey, McGregor, McNeil, McLeary, and so on. Pay might be $2 to $3 a day for

Month of *August* 188**3**

15	16	17	18	19	20	21	22	23	24	25	26	27	28	29	30	31	Total Time.	Rate p. day	AMOUNT $	Cts.
/	/	/	/	/	/	/	/	/	/	/	/	/	/	/	/	/	31	4½	139	50
/	/	/	/	/	/	/	/	/	/	/	/	/	/	/	/	/	27	3	87	00
½	/	/	/	/	/	/	/	/	/	/	/	/	/	/	/	/	31	3¾	116	2
/	/	/	/	/	/	/	/	/	/	/	/	/	/	/	/	/	31	3	93	00
/	/	/	/														18⅜	3	55	50
/	/	/	/	/	/	/	/	/	1½	/	/	/	/	/			31	3	93	00
	/	/	x	/	/	/	/	/	/	/	/						12	3	36	00
Given																	9⅔	3	28	60
/	x	x	x	x	x	x	x	x		/	/	/	/	/			23⅔	3¾	88	12
/	/	/	/	/	/	/	/	/	/	/	/	/	/	/			29	3	87	00
/	/	/	/	/	/	/	/	/	²⁄	/	/	/	/	/			31	3	93	00
/	/	/	/	/	/	/	/	/	½	/	/	/	x	x			29	3	87	00
/	/	/	/	/	/	/	/	/	½	/	/	/	/	/			31	3	93	00
/	/	/	/	/	/	/	/	/	²⁄	/	/	/	/	/			29⅔	3	88	50

10 or 12 hour shifts. (Salida Museum Association)

You didn't have to be a prospector to lose your shirt in the mountains. Many people saw life savings disappear in mine stock. Of course, others made fortunes. (Salida Museum Association)

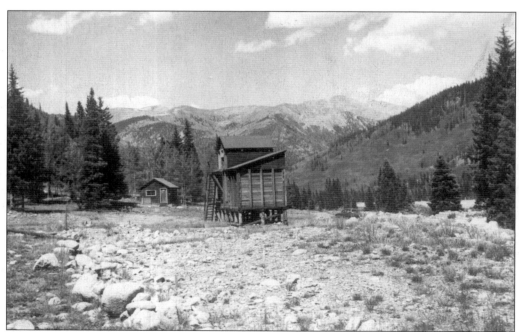

High in the mountains, the view was lovely but it could be a hard and lonely life. (Salida Museum Association)

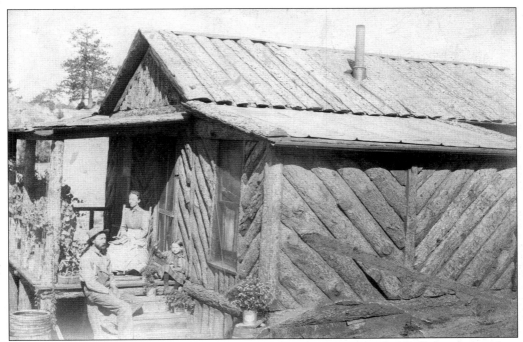

This lucky family had a substantial house to weather the sometimes harsh Colorado weather. (Salida Museum Association)

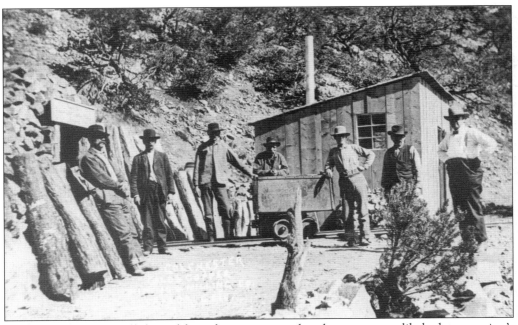

These men were too well-dressed for ordinary mine work—they were most likely the operation's management. (Salida Regional Library)

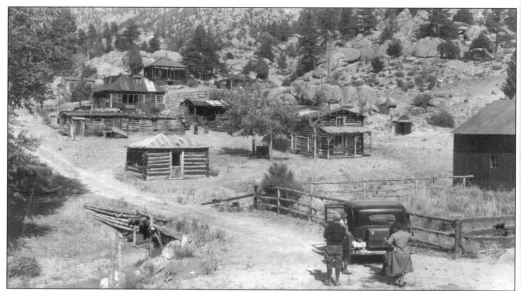

The building at the far right was the stagecoach stop in the earlier days at the Turret mining camp. By 1930, the buildings were abandoned and all that remained was the history. (Salida Museum Association)

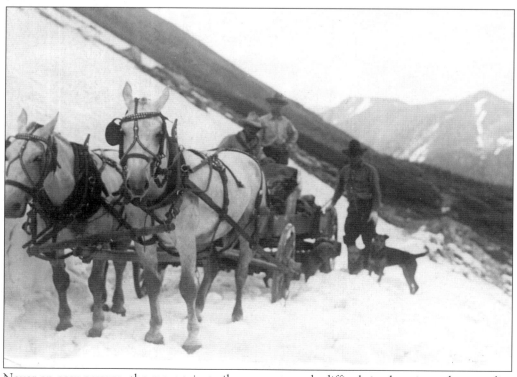

Never an easy passage, the mountain trails were extremely difficult in the winter, but supplies had to get through. (Salida Museum Association)

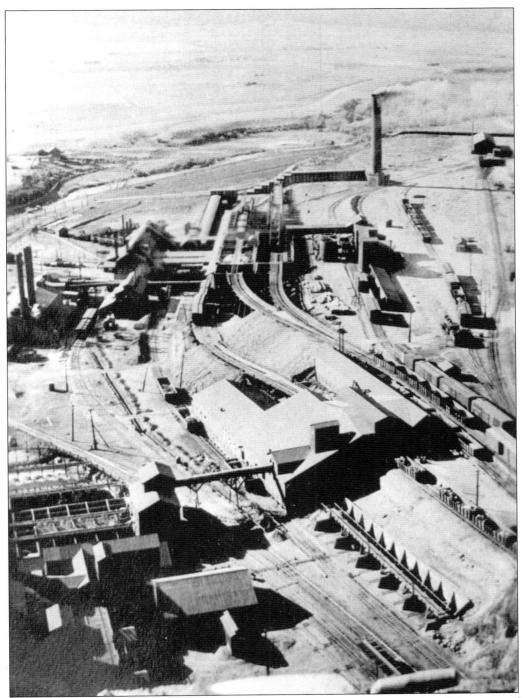

Established in 1901 to process ore from the mountains, the smelter provided work for many of Salida's residents for almost 20 years. Molten silver and lead flowed from furnaces that never cooled, and stacks, one of them 365 feet high, carried sulfur high into the winds to reduce harmful effects to plants and animals downwind. (Salida Regional Library, Frank Thomson)

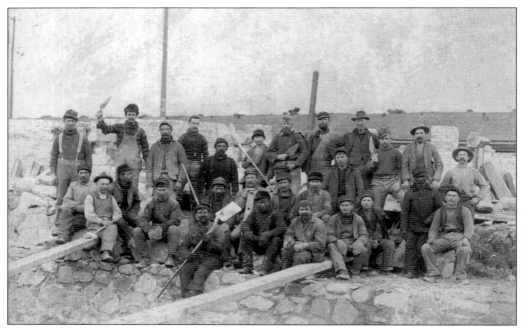

Some of the men who worked the 12-hour shifts at the smelter lived with their families in the community called Smeltertown that surrounded the plant near Salida. The tall stack is all that remains of the once-thriving plant. (Salida Museum Association)

The many faceted Colorado Coal and Fuel Company was organized in 1880. One part of the operation, the quarry, is shown in this 1945 photograph. (Salida Ranger District, San Isabel National Forest)

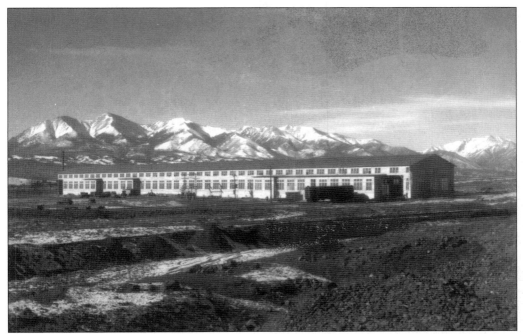

Prized granite was mined around the area and several companies established businesses near the town. The photo shows the Stonehenge Granite Company of Salida. (Salida Museum Association)

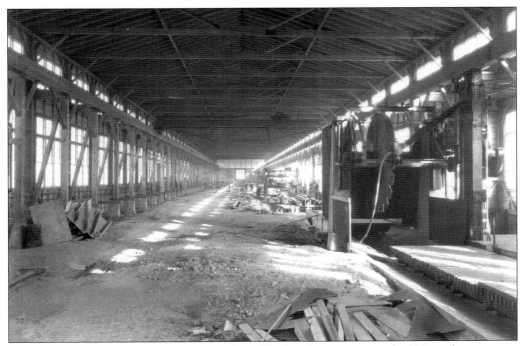

This giant saw was used to cut through huge blocks of granite around 1930, and was water-cooled. (Salida Museum Association)

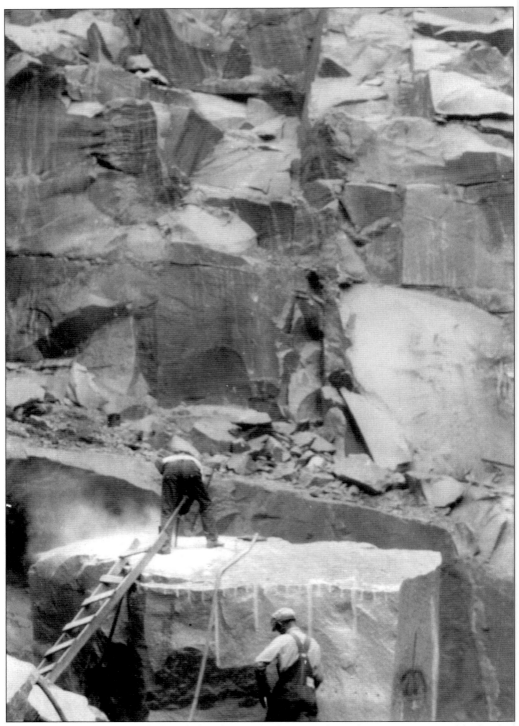

Men were dwarfed as the drill and chisel wrenched granite from the mountain into blocks that were customized to order. (Salida Museum Association)

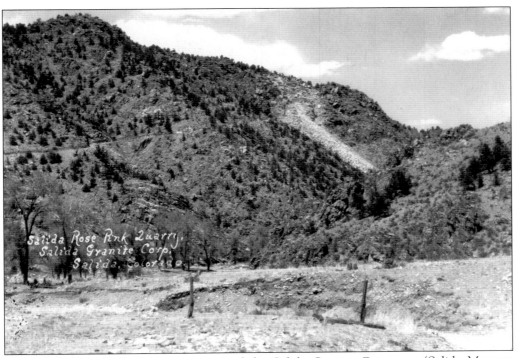

The Salida Rose Park Quarry was part of the Salida Granite Company. (Salida Museum Association)

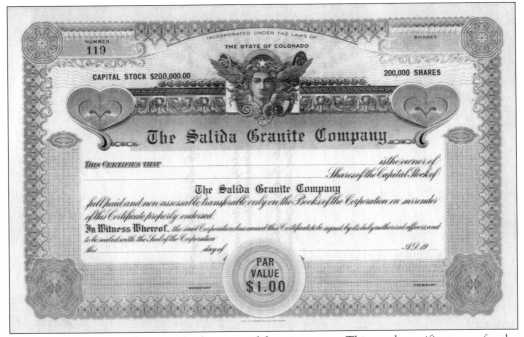

Many of the mining industries relied on capital from investors. This stock certificate was for the Salida Granite Company. (Salida Museum Association)

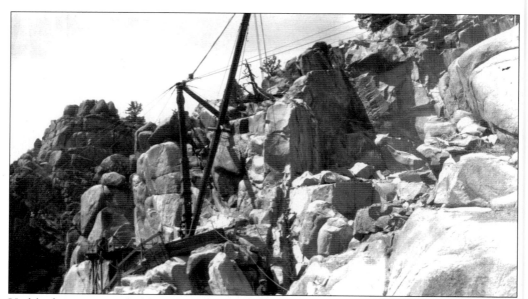

Highly dangerous work, blocks of granite weighing many tons were dislodged and moved with equipment built especially for the purpose. (Salida Museum Association)

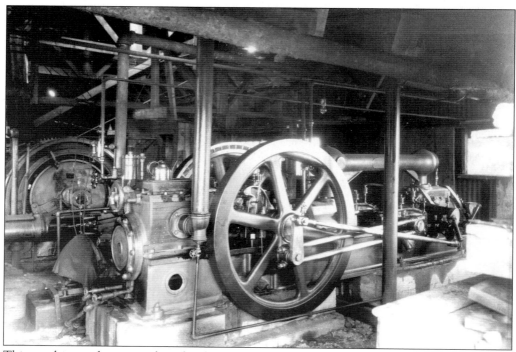

This machinery shop was silent for this photographed moment but normally was a very busy place. (Salida Museum Association)

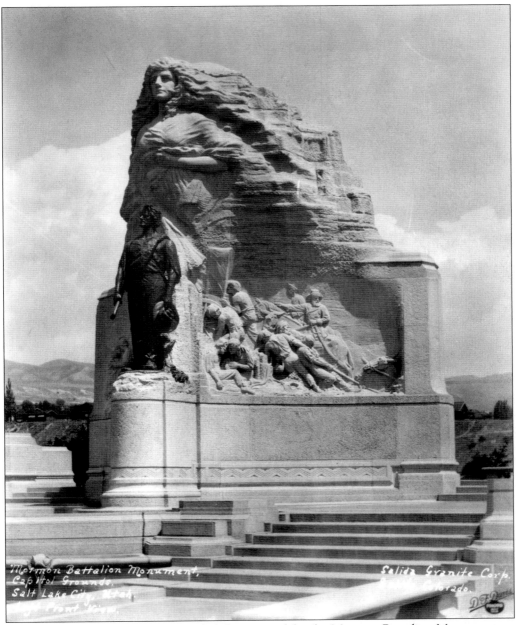

The Salida Granite Company provided the material for the Mormon Battalion Monument on the capitol grounds in Salt Lake City, Utah. (Salida Museum Association)

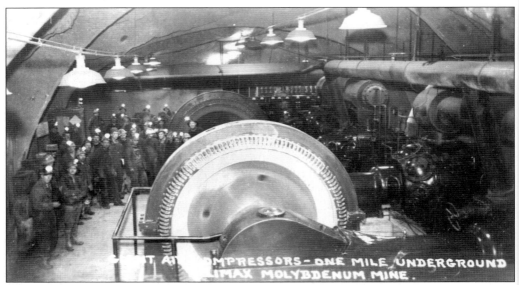

Hard to pronounce, molybdenum was often called Molly-be-damned by locals. The mineral was used to strengthen steel and its mining provided work for many in Salida. (Salida Museum Association)

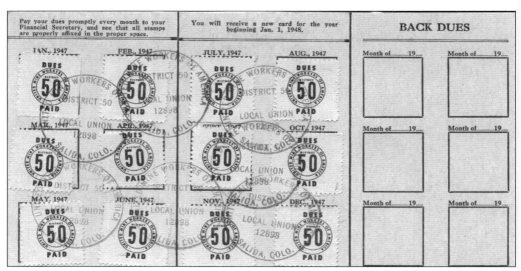

Establishing unions in the mining districts was a painful process and sometimes deadly, but eventually they were accepted. This worker paid 50¢ a month in 1947. (Salida Museum Association)

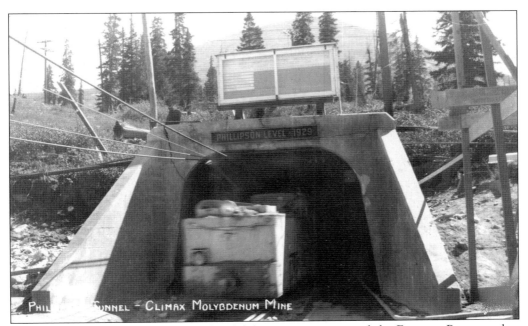

Assay reports as early as 1879 proved molybdenum present around the Fremont Pass area, but this was disappointing news since the prospectors were looking for gold. Subsequent world wars and the automobile industry would prove the mineral to be of great importance to the whole area. This is the Climax Mine tunnel in the 1940s. (Salida Museum Association)

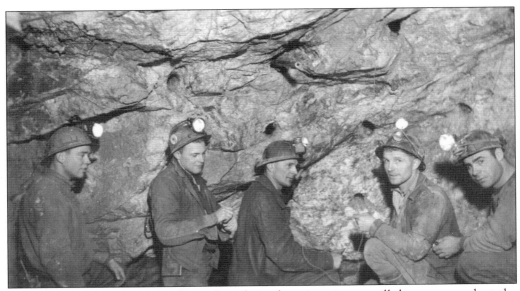

While safety practices improved significantly in the mines, it was still dangerous work at the Climax Mine in the 1940s. These men packed holes with detonating charges, releasing ore for collection, shipment, and processing. (Salida Museum Association)

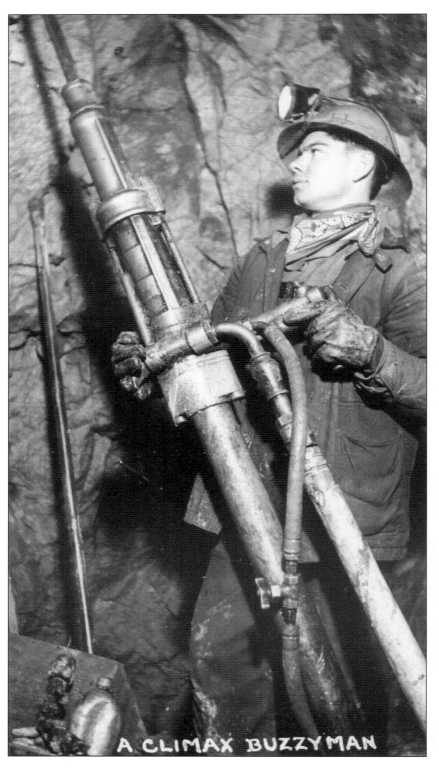

A CLIMAX BUZZYMAN

The Climax Buzzyman was only one of the many skills required to produce molybdenum. The operation was a mainstay in the economy until 1987 when the mine closed its tunnels for the last time. (Salida Museum Association)

Three
RAILROADS

Denver and Rio Grande Railway founder General Palmer planned a railroad to supply fuel and material to mines, mills, and other industries. In 1880 his narrow gauge railroad came to Salida, the designated division point, and the city prospered with the Iron Horse.

For 100 years the trains ran through Salida, leaving their indelible print on the history of the community and providing jobs for many families as well as a way of life. In the 1980s the Denver and Rio Grande pulled up stakes and moved its operation further north.

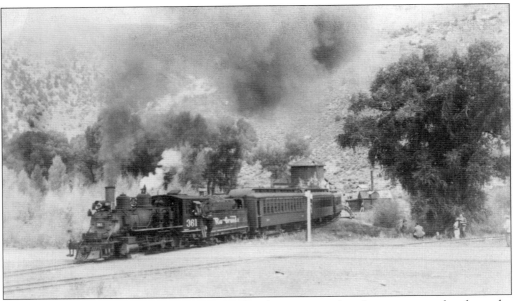

Steam trains required frequent stops to replenish water supplies from water tanks along the routes. The brief stops gave passengers a chance to get off the train, stretch their legs, and look around the small settlements. (Salida Museum Association)

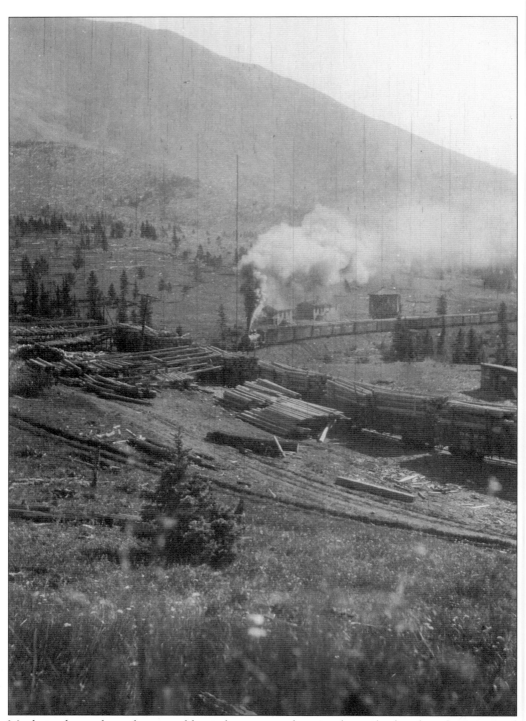

Much in demand, easily accessible timber was used up in the early decades of mining and building the railroad. This "timber train" went to the higher elevations to pick up loads. (Salida Ranger District, San Isabel National Forest)

Located between Tenderfoot Hill and the Arkansas River, the train depot was a busy place. Freight was loaded as passengers debarked and headed for the Monte Cristo Hotel shown in the center of this 1895 photograph. (Salida Regional Library, Alice Chinn)

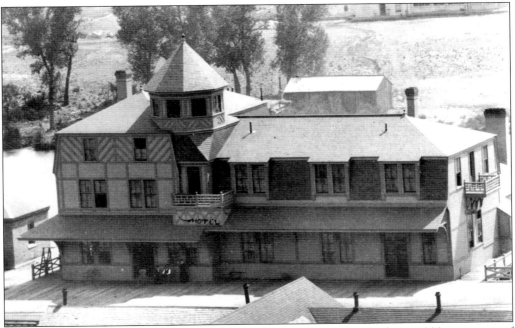

Soon after the trains appeared in Salida, the Monte Cristo was built in 1883 at a cost of $38,000. Known for fine dining, it created the Monte Cristo sandwich that combined turkey, ham, and Swiss cheese, was dipped in batter, deep-fried, and served with currant jelly. The unusual concoction was copied in restaurants around the country and can still be found on First Street. (Salida Museum Association)

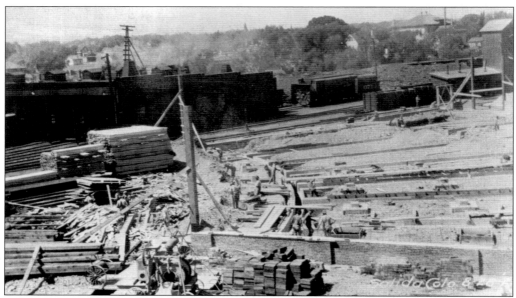

Locating the railroad hub in Salida insured the growth of the town for many years. (Salida Regional Library, Harry Williams)

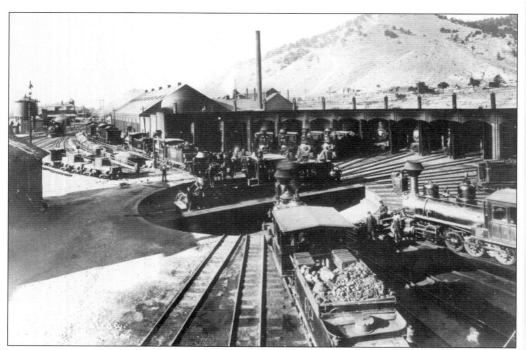

The roundhouse enabled trainmen to house the engines for repairs and shuttle locomotives to different rails. (Salida Regional Library, John Ophus)

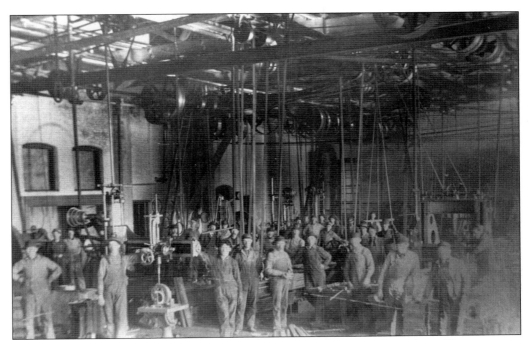

The train shop was a busy, noisy place with humming belts strung from the ceiling to power machines below. Activity was momentarily stilled while a long exposure was taken for this photo. (Salida Regional Library, John Ophus)

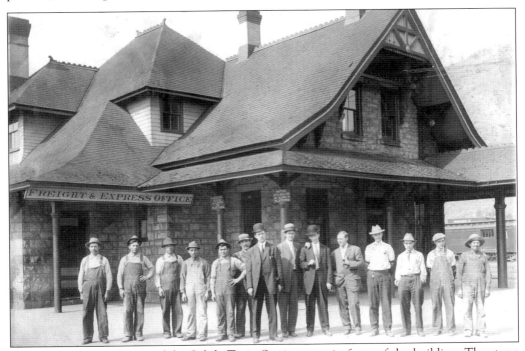

Management and laborers of the Salida Train Station pose in front of the building. The stone depot was built around 1882. (Robert Rush)

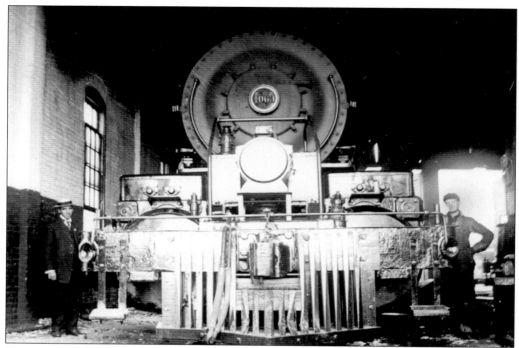

Engines were regularly sent to the roundhouse for routine repairs and general maintenance. (Salida Regional Library, Josephine Soukup Kratky)

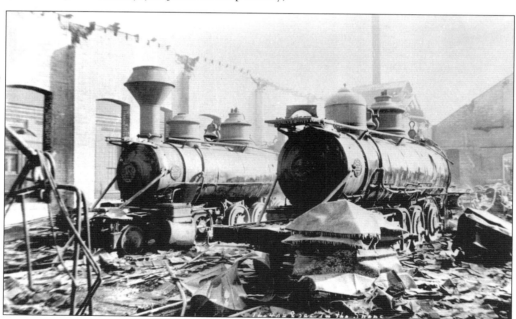

Despite efforts of local firefighters, in December 1892 a fire left the Denver and Rio Grande roundhouse and shop at Salida seriously damaged and some of the engines destroyed. Over 100 employees were out of work until the facility could be replaced. (Salida Regional Library, Steve Frazee)

Salida Mch 7 1889

Geo R. Simmons

To **THE DENVER AND RIO GRANDE RAILROAD CO.—EXPRESS DEP'T,** *Dr.*

For Freight on 1 Pa _____ Weighing 6½ Lbs.

W. B. No. 65 Dated Mch 6 1889 from Pueblo _____ Freight, $.50

Charges Advanced, - - - - - - - $ 1.10

C. O. D. - - - - - - - - -

Return Charges, - - - - - - -

Returned from Salida California additional charges 60¢ MBL

Total, - - - $ 1.60

Received Payment, WM Luther Agent.

In 1889, freight costs for a parcel sent from Pueblo to Salida were $1.60 on the Denver and Rio Grande Railroad. (Salida Museum Association)

Running on steam power, the trains refilled water tanks and took on fuel at selected points along the routes, but needed to stop for water three times as often as fuel. In a land of light rainfall, water tanks had to have a water source available to replenish their reserve, usually a well. (Salida Museum Association)

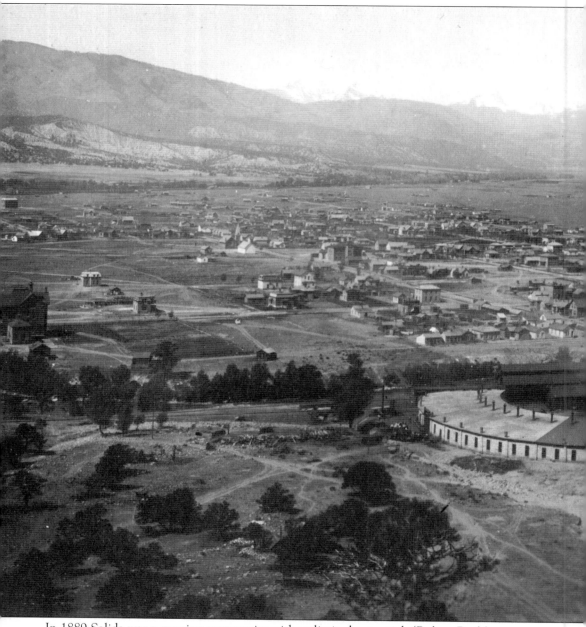

In 1889 Salida was a growing community with unlimited potential. (Robert Rush)

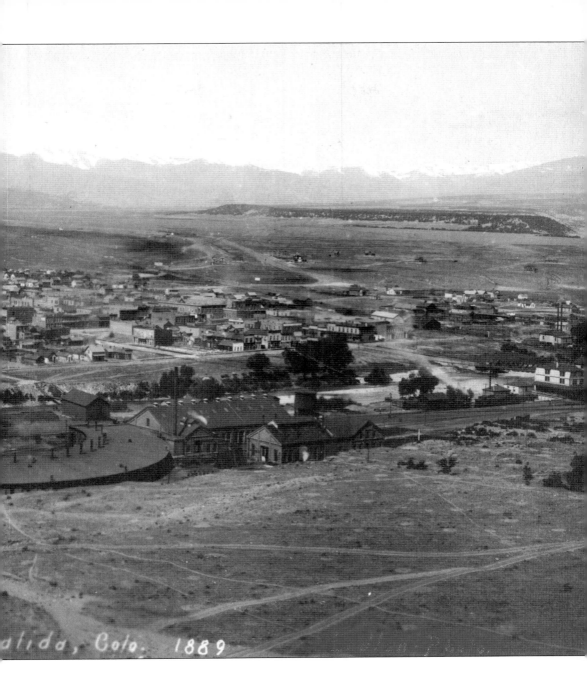

Salida, Colo. 1889

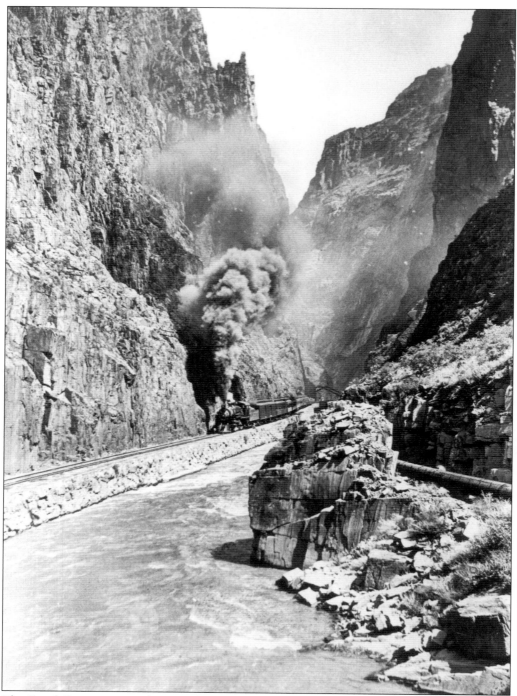

The Royal Gorge presented extraordinary challenges to the civil engineers and crews building the railroad. (Salida Regional Library, Leonard Perschbacker)

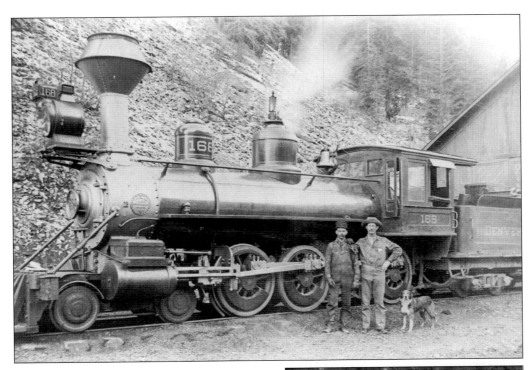

This dog joined the train crew for a photo. Duke, another dog in Salida history, was owned by the manager of the railroad hotel and met train passengers at the station. He was much loved and after his death at the age of 13, a memorial to Duke was placed on Tenderfoot Hill and remains there today. (Salida Regional Library)

After the enormous challenge of laying track for the railroad, the beauty of the Colorado mountains were available for tourists. The long cars on this train suggest the time was around 1930. (Salida Museum Association)

Henry Smith was the stationmaster at Marshall Pass around the time this early 1900s photo was taken. His duties included being the resident telegraph operator and relaying orders to the train engineer about the schedule and freight. (Salida Museum Association)

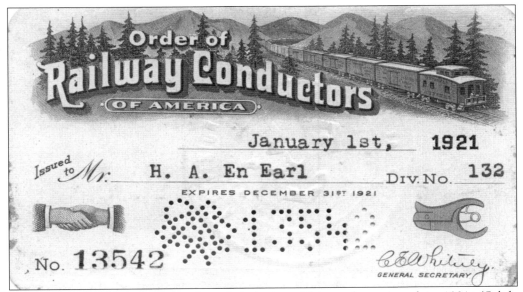

Railway conductors organized and paid their dues. This card was issued in 1921. (Salida Museum Association)

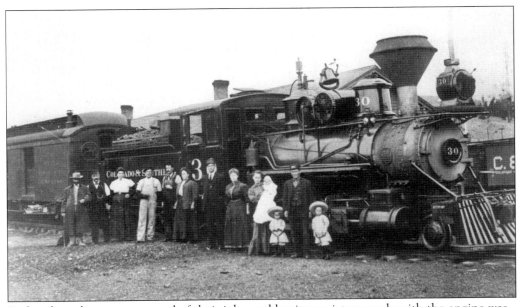

Railroad employees were proud of their jobs, and having a picture made with the engine was sometimes a family affair. (Salida Regional Library, Leonard Perschbacker)

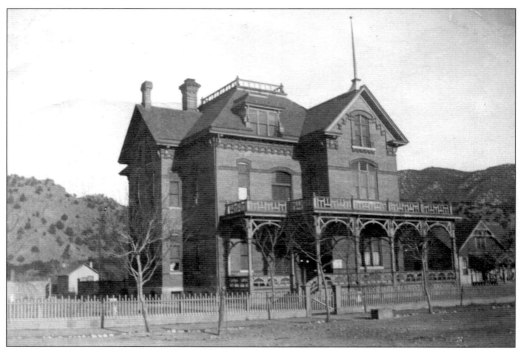

The railroad built a hospital in Salida from monies collected from every railroad employee's monthly check. The facility served the employees and their families. (Salida Museum Association)

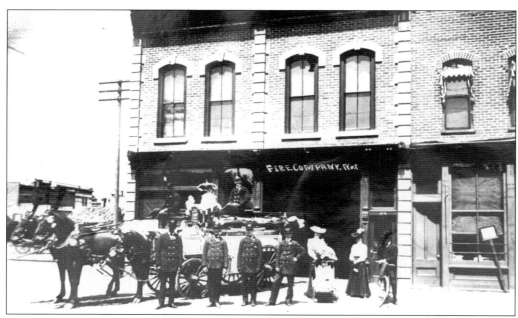

Fire was always a danger in Salida, and the local fire department was sometimes called to the railroad as well as protecting the town's buildings and homes. (Salida Regional Library, John Ophus)

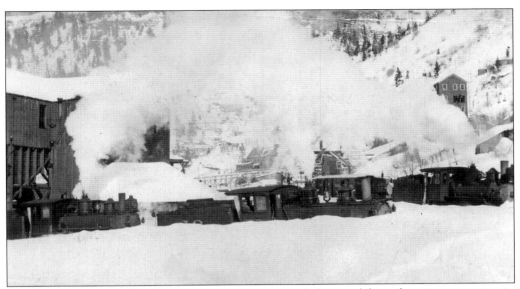

The businesses of Salida and surrounding towns depended on coal from the mines to maintain production and to heat homes. The coal trains ran in all but the worst of weather. (Salida Museum Association)

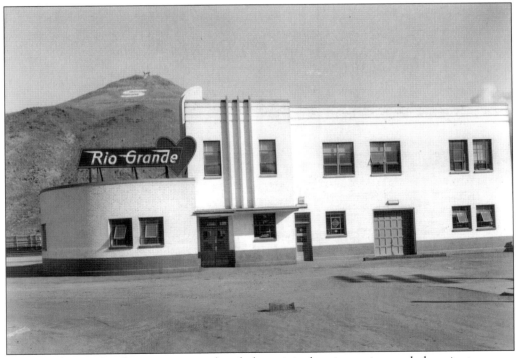

Built in the 1930s, this structure replaced the original train station and then in turn was demolished in the 1980s when the trains no longer came. (Salida Museum Association)

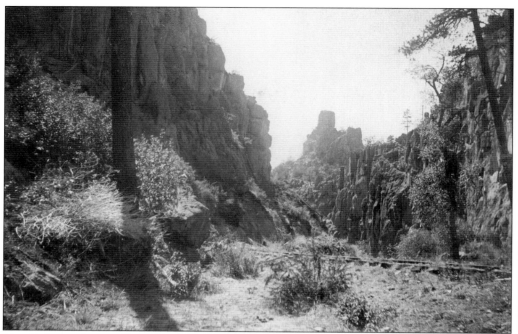

The Calumet line to Turret was the only seven percent grade known in railroading. (Salida Museum Association)

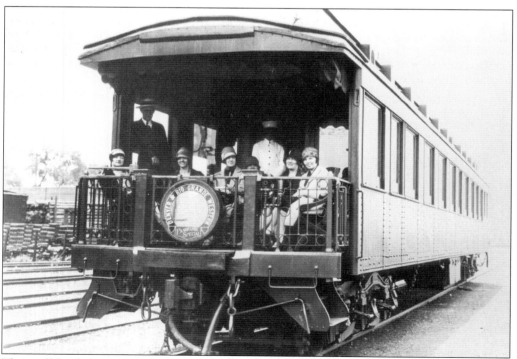

This well-heeled group waited on a siding for an outing. (Salida Regional Library, Leonard Perschbacker)

Four

FOREST

The mountains around Salida were well-forested and provided fuel and habitat for living creatures. Ute Indians hunted game, trappers harvested fur-bearing animals, miners used timber to build sluices and shore up mine shafts, and railroads required uncounted trees for track ties. Among other things, an increasing population, the insatiable charcoal industry, and toxic wastes all took their toll on the forests. Eventually, entire areas were barren, exposing the soils to erosion.

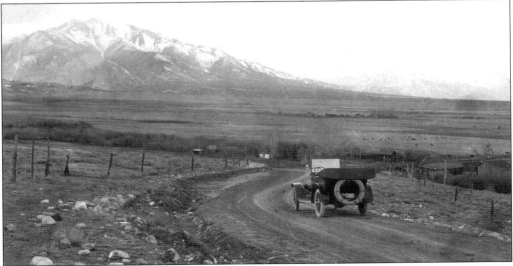

The West was full of spaces, and the automobile made them accessible to many in the 1930s. (Salida Ranger District, San Isabel National Forest)

The Marshall Pass Ranger Station Barn was built in 1935. (Salida Ranger District, San Isabel National Forest)

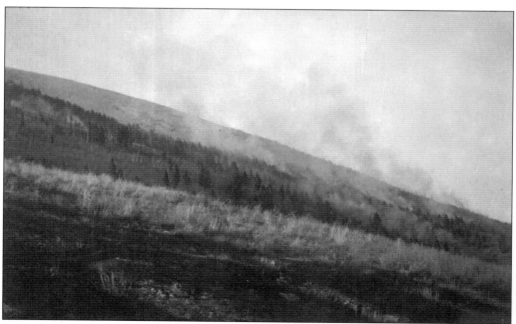

In 1910, the Marshall Pass fire destroyed thousands of acres of forest. (Salida Ranger District, San Isabel National Forest)

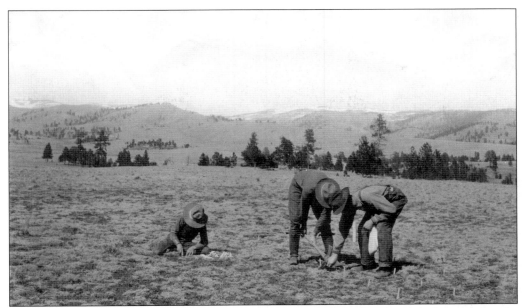

After years of plunder for fuel, mine work, building of the railroads, and charcoal for the smelters, many areas in the mountains were bare of trees. The Forest Service started replanting programs to renew the severely depleted natural resource. (Salida Ranger District, San Isabel National Forest)

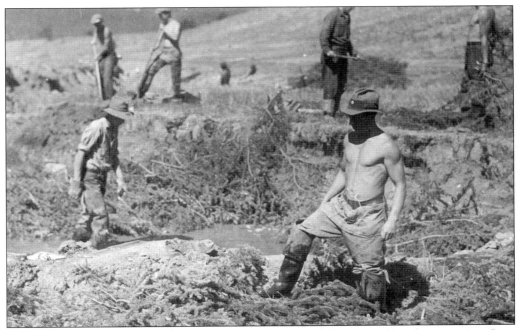

Established in 1933 by President Franklin Delano Roosevelt, the Civilian Conservation Corp was charged with conserving the country's timber, soil, and water resources as well as providing employment and training for young men during the Depression. This crew is working on erosion control. (Salida Ranger District, San Isabel National Forest)

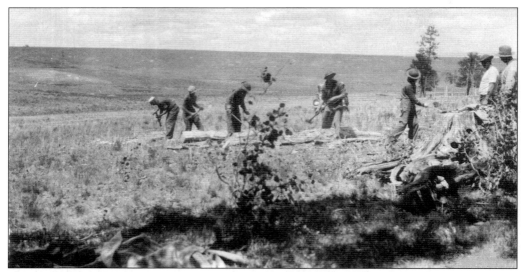

This Civilian Conservation Corp unit was put to work splitting posts. Employing unmarried men between the ages of 17 and 23, the job paid $30 a month. The program employed about three million men for reforestation, construction of fire towers, laying telephone lines, and development of state parks. Congress abolished the program in 1943. (Salida Ranger District, San Isabel National Forest)

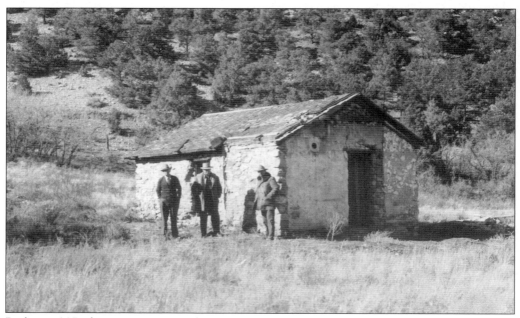

Built in 1907, this ranger station also served camping boy scouts as well as regular use by the Forest Service. (Salida Ranger District, San Isabel National Forest)

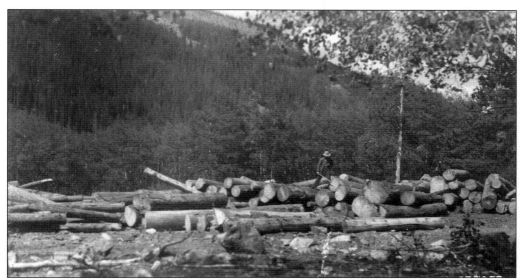

By 1945, forest utilization programs meant cutting trees for use in some productive way. This man is scaling bark from logs, preparing them for shipment to a mill. (Salida Ranger District, San Isabel National Forest)

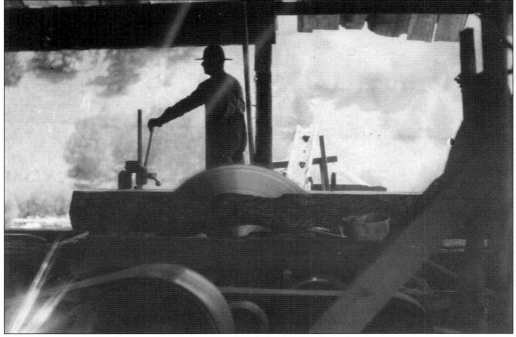

Use of the rich resources of timber often required sawmills for custom cutting of the logs. Since the early days up to the present, small sawmills have dotted the area. (Salida Ranger District, San Isabel National Forest)

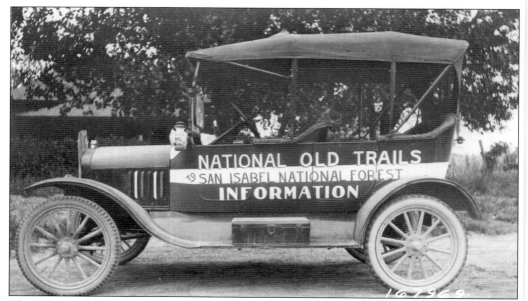

The Arkansas Valley Garage Men's Association outfitted this car to publicize their work and to provide information about the Forest Service, 1922. (Salida Ranger District, San Isabel National Forest)

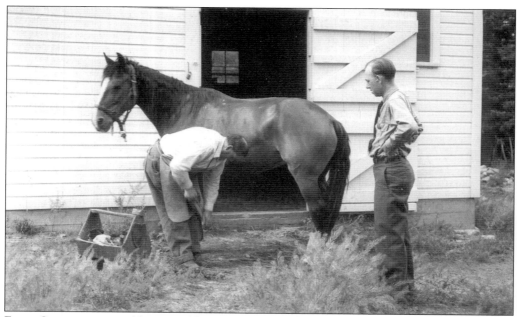

Forest Service personnel have used horses in the San Isabel range since its inception. Well into the 1940s, farriers were still shoeing animals for backwoods trail work. (Salida Ranger District, San Isabel National Forest)

Five

THE TOWN

*B*y 1889 Salida had 5,000 residents, almost 100 telephones, and the beginnings of a public power and light system. Mining and the railroad gave the town a huge jump start, but local businesses proved to be the stable foundation that would weather economic storms in the new century.

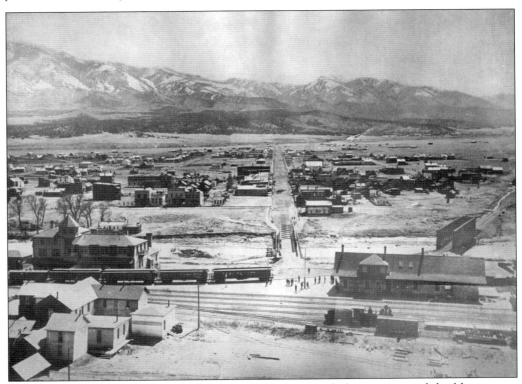

After several disastrous fires in the late 1880s, most of the commercial buildings were constructed of brick, as can be seen in this turn-of-the-century photograph of Salida. (Salida Museum Association)

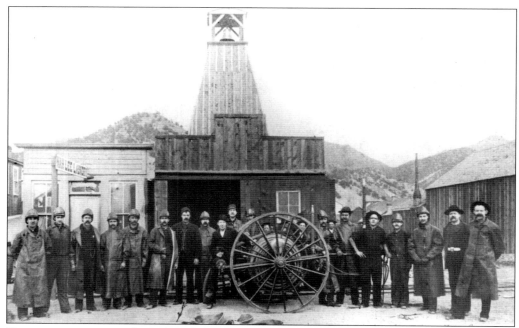

Fires were a constant hazard and fire crews were at the ready. But even this department eventually lost its tower to flames. (Salida Regional Library, Alice Chinn)

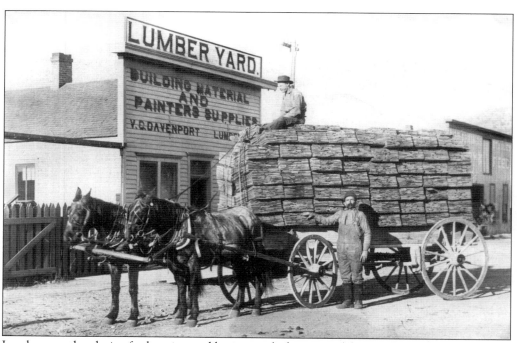

Lumber was the choice for housing and businesses before several fires in the 1880s nearly wiped out the town. Eventually, building codes required brick construction. (Salida Museum Association)

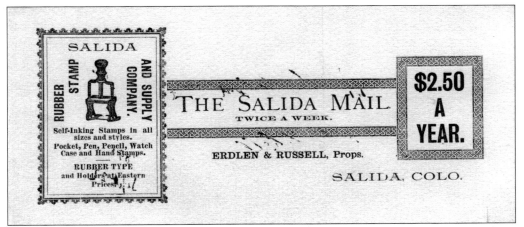

Area newspapers came and went, changed hands, changed names, and over the years, Chaffee County had dozens heralding the news. A *Salida Mail* subscription was available for $2.50 a year and later became *The Mountain Mail*. (Salida Museum Association)

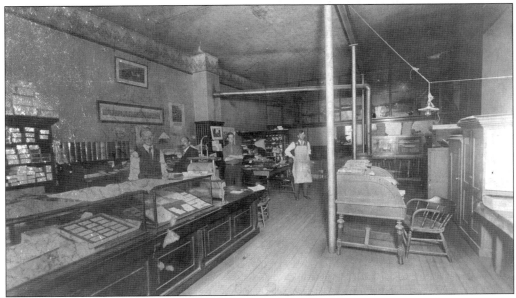

The *Salida Mail* office published a newspaper and offered printing services to the community since its beginning *c*. 1880. (Salida Museum Association)

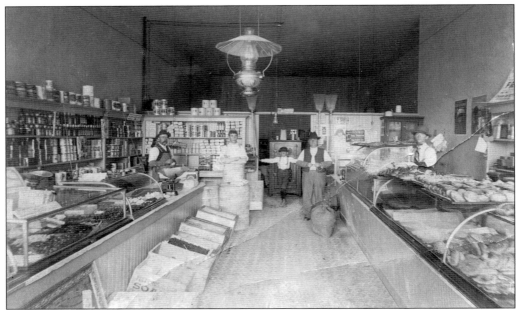

In 1891, the Whitehurst & Gillet Grocery offered tinned goods, bakery items, home canned produce, candy, and brooms. The store utilized both kerosene and electric lights. (Salida Museum Association)

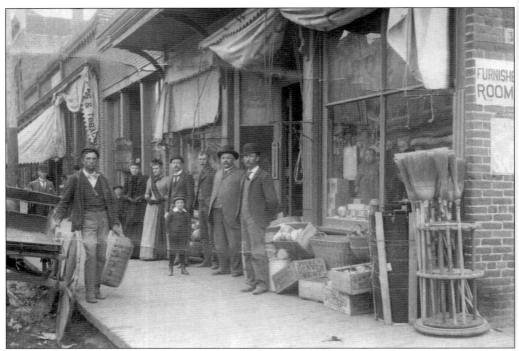

The Whitehurst & Gillett Grocery displayed many of its wares on the wooden sidewalk in front of the store. While the group outside patiently waits for the long photo exposure, a small child peers out from inside the window. (Salida Museum Association)

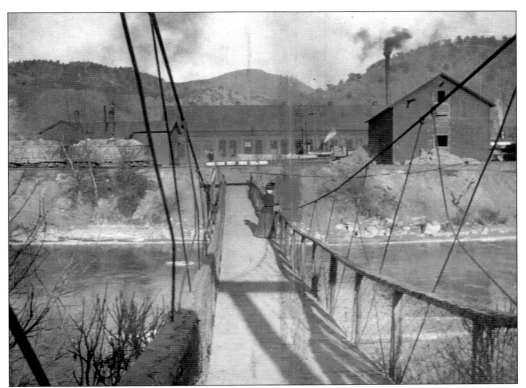

The swinging bridge over the Arkansas River was the gathering place for Memorial Day celebrations as people threw flowers in the river. In 1904, the bridge collapsed, drowning several children and an adult. (Salida Museum Association)

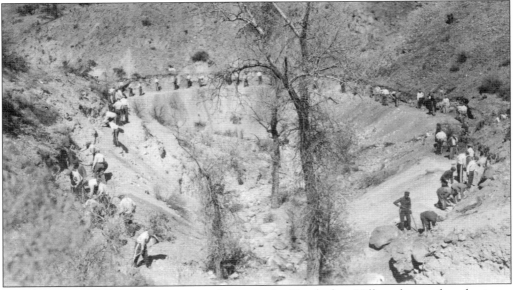

Built by prison labor and community volunteers, the Tenderfoot Hill road wound to the top, offering a panoramic view of the valley. (Salida Museum Association)

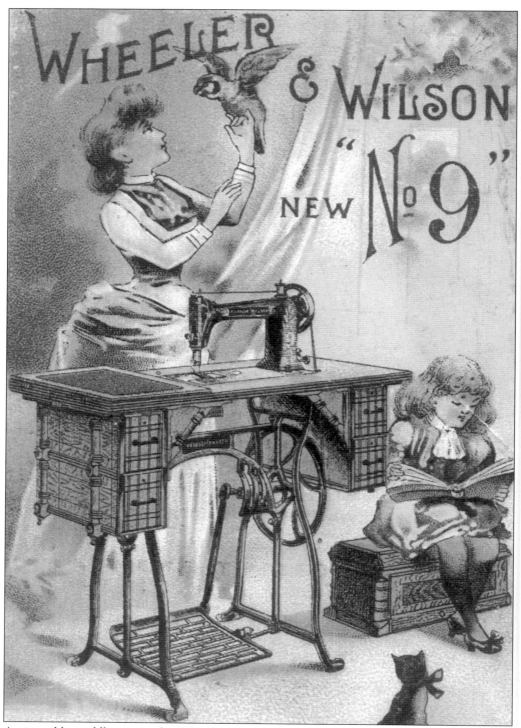

Activated by peddle power, the Wheeler & Wilson No. 9 sewing machine was a fixture in many homes from the late 1800s. (Salida Museum Association)

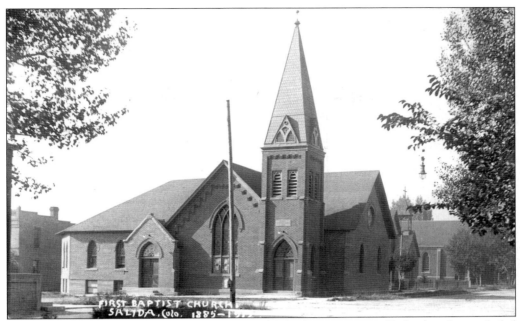

Churches were one of the first organizations established in new towns. Early churches included the Congregation United Church of Christ, the First Baptist Church (pictured), First Christian Church, St. Joseph Parish, Salida Presbyterian Church, and the Seventh-Day Adventist Church, as well as others. (Salida Museum Association)

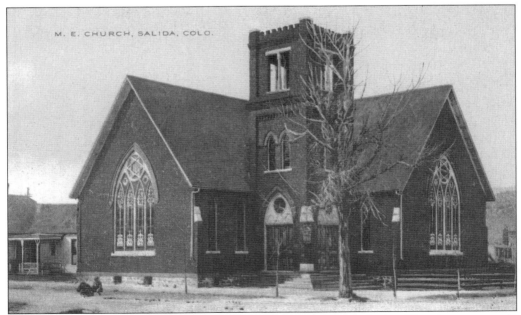

Built in 1899 and escaping two fires in the 1930s, the Salida Methodist Church was recently put on the National Historic Register. A 1907 pipe organ, original stained glass windows, and vaulted wood ceilings are only a few of the distinguishing features of this treasure. (Beth Smith, Methodist Church)

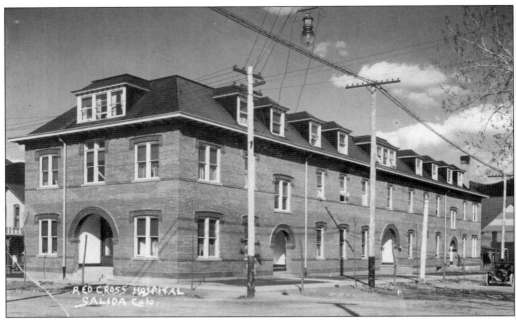

Built in 1910 at Third and G Streets, the Red Cross Hospital served the community as a medical facility and a nurses' teaching school. A dream of Dr. F.N. Cochems, the establishment closed in 1941. It is now the Salida Masonic Temple. (Salida Museum Association)

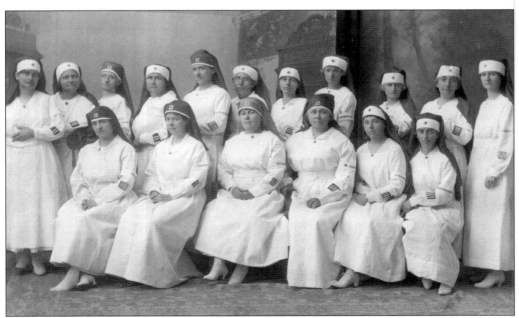

For many years, two to eight nurses graduated from the Salida Red Cross Hospital in every class. (Salida Museum Association)

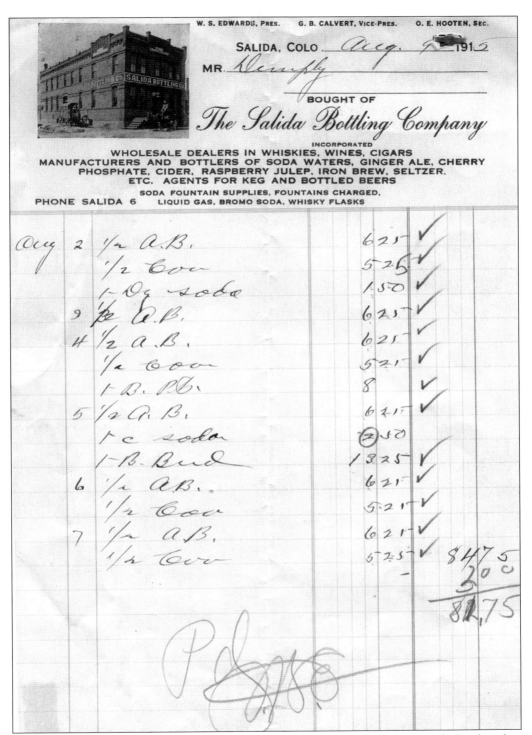

SALIDA, COLO. *Aug.* 9 1915

MR. *Dempsy*

BOUGHT OF

The Salida Bottling Company

INCORPORATED
WHOLESALE DEALERS IN WHISKIES, WINES, CIGARS
MANUFACTURERS AND BOTTLERS OF SODA WATERS, GINGER ALE, CHERRY
PHOSPHATE, CIDER, RASPBERRY JULEP, IRON BREW, SELTZER.
ETC. AGENTS FOR KEG AND BOTTLED BEERS
SODA FOUNTAIN SUPPLIES, FOUNTAINS CHARGED,
PHONE SALIDA 6 LIQUID GAS, BROMO SODA, WHISKY FLASKS

Aug	2	½ A.B.	6 25	✓
		½ Coo	5 25	✓
		1 Dg soda	1 50	✓
	3	½ A.B.	6 25	✓
	4	½ A.B.	6 25	✓
		½ Coo	5 25	✓
		1 B. P.B.	8	✓
	5	½ A.B.	6 25	✓
		1 c soda	(2) 50	
		1 B. Bud	13 25	✓
	6	½ A.B.	6 25	✓
		½ Coo	5 25	✓
	7	½ A.B.	6 25	✓
		½ Coo	5 25	✓ 84 75

3 00
82 75

The Salida Bottling Company kept the delivery wagons rolling with their stock. Produced in Golden, Colorado, Coors beer was a big seller for the distributor. (Salida Museum Association)

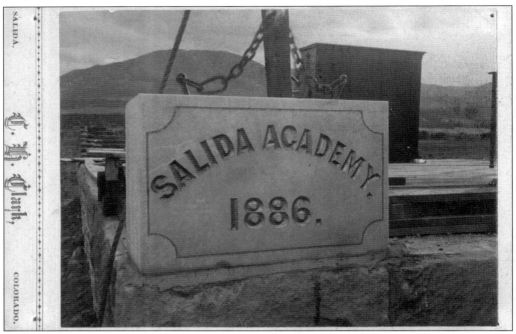

Built in 1886, the Salida Academy joined the numbers of private and public schools in the area. (Salida Museum Association)

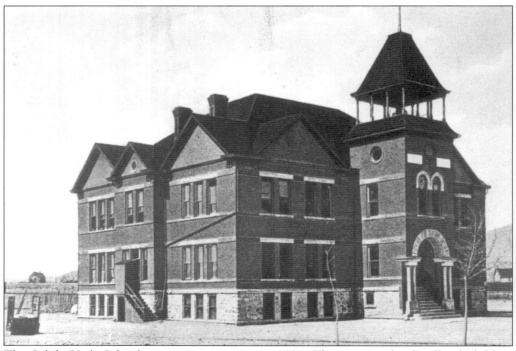

The Salida High School cornerstone was set in 1892. The town's schools offered children scholastic, social, and sports activities. (Salida Regional Library, Alice Chinn)

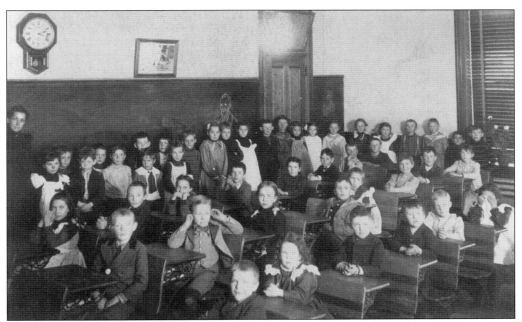

Classrooms have not changed so much in 100 years. The clothes might be a little different but there are still drawings on the blackboard, a large number of children to teach, and everyone anxious to go home in the afternoon, especially in this 1902 schoolroom. (Salida Museum Association)

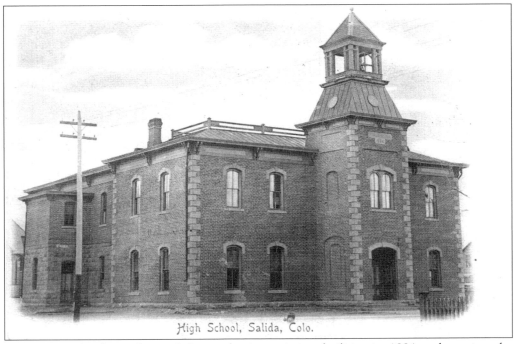

High School, Salida, Colo.

A growing school population led to enlarging existing facilities in 1884 and naming the building Central High School. Nearly 50 years later, the name was changed to McCrary, honoring a teacher and principal. (Salida Museum Association)

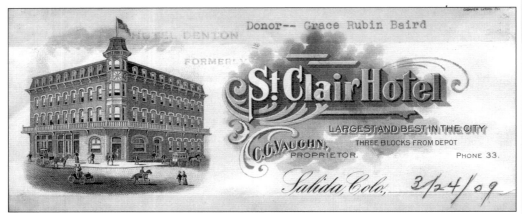

The St. Clair Hotel was one of the first three-story buildings in Salida, 1909. Today, the town is still down to earth with only the mountains rising high in the sky. (Salida Museum Association)

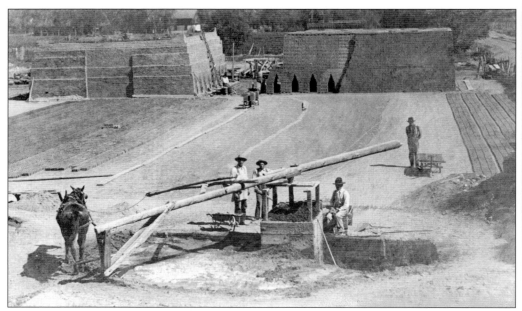

Working in the brickyards was hot and dusty work but there were large and small operations to accommodate the huge demand for building materials. (Salida Regional Library, Pearl Lunnon)

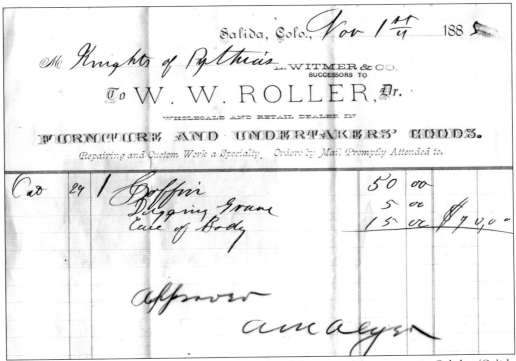

Salida, Colo., Nov 1st/4 188 5

M. Knights of Pythias
L. WITMER & CO.
SUCCESSORS TO
To W. W. ROLLER, Dr.

WHOLESALE AND RETAIL DEALER IN

FURNITURE AND UNDERTAKERS' GOODS.

Repairing and Custom Work a Specialty. Orders by Mail Promptly Attended to.

Oct	29	1 Coffin		50	00	
		Digging Grave		5	00	
		Care of Body		15	00	$70.00

Approved

Analysis

Furniture sales and undertaking went hand in hand for several businesses in Salida. (Salida Museum Association)

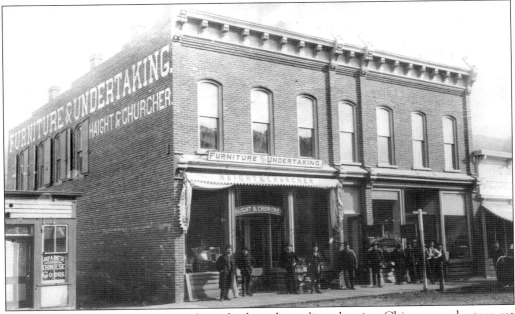

Serving the railroad crews with ethnic foods and supplies, the tiny Chinese goods store sat beside the Haight & Churcher Furniture & Undertaking establishment late in the 1800s. (Salida Museum Association)

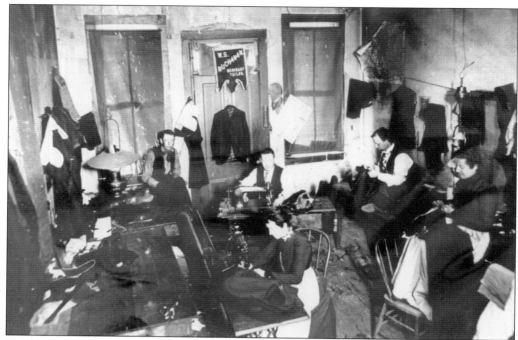

Working in cramped quarters, men and women labored to produce tailored clothing for Salida's well-to-do. (Salida Regional Library, John Ophus)

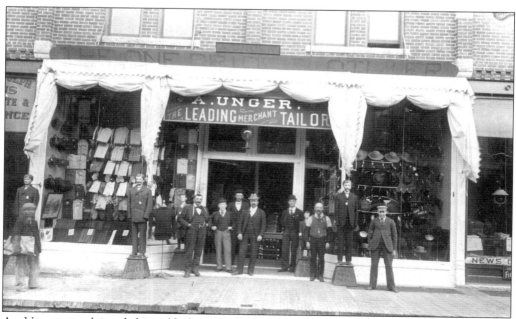

A. Unger proclaimed himself the "Leading Merchant Tailor" above the door to his establishment. Wares were displayed on mannequins. The salespeople stood in front of the store for this photo, *c*. 1900. (Salida Museum Association)

The Opera House program displayed ads from the local businesses, and the Windsor Café promised "Anything You Want" and "The Best Service in City," 24–7. (Salida Museum Association)

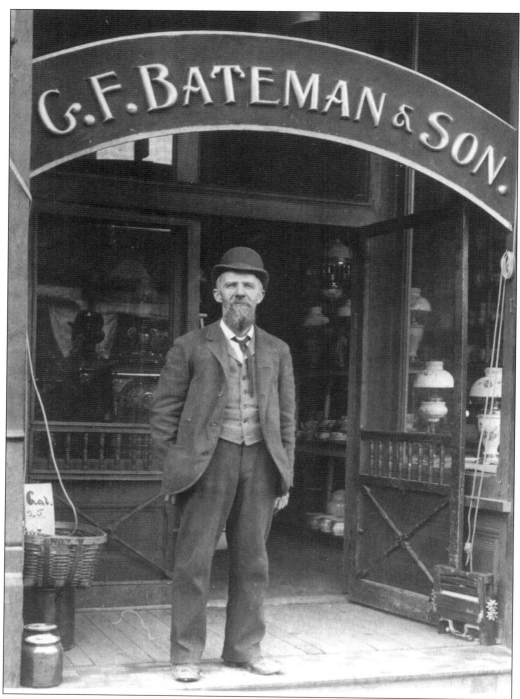

G.F. Bateman was one of the first merchants in young Salida in 1880. Early commerce also included banks, hotels, barbershops, a furniture store, lumber dealers, saloons, doctors, attorneys, an architect, contractors, several newspapers, a tobacco shop, and a Chinese laundry. (Salida Museum Association)

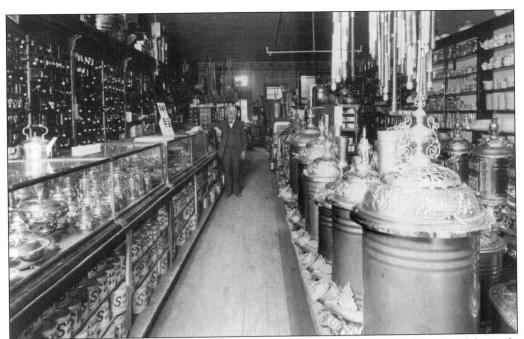

Bateman Hardware was the place to find the mainstay of many homes, like the elaborately decorative heat stove that would burn wood or coal through winter's cold. Other items included kitchen crockery, drapery rods, fine silverware for the table, and paint for the walls. (Salida Museum Association)

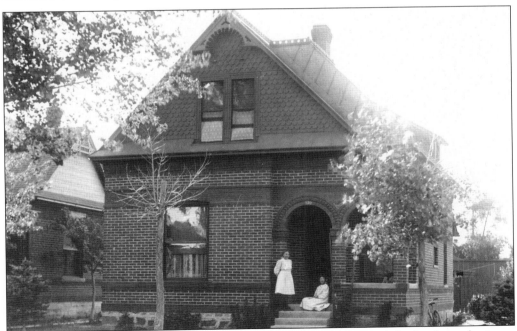

The Bateman House was modest but reflected the solid prosperity of the hardware business. (Salida Museum Association)

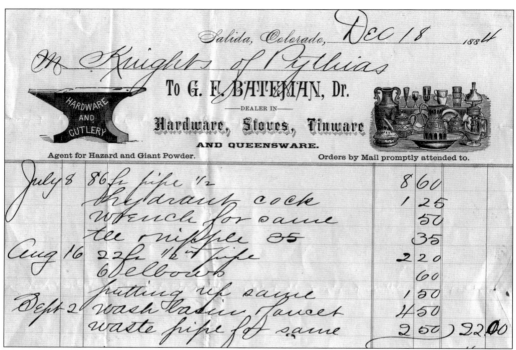

Salida, Colorado, DEC 18 1884

M. Knights of Pythias

To G. F. BATEMAN, Dr.

—DEALER IN—

Hardware, Stoves, Tinware

AND QUEENSWARE.

Agent for Hazard and Giant Powder. Orders by Mail promptly attended to.

July 8	86 ft pipe 1/2			8	60	
	hydrant cock			1	25	
	wrench for same				50	
	tee + nipple 35				35	
Aug 16	22 ft 1/2 + pipe			2	20	
	6 elbows				60	
	putting up same			1	50	
Sept 2	wash basin faucet			4	50	
	waste pipe for same			2	50	22 00

This Bateman invoice dated 1884 for the Knights of Pythias may have been for building or repair of the organization's meeting place. (Salida Museum Association)

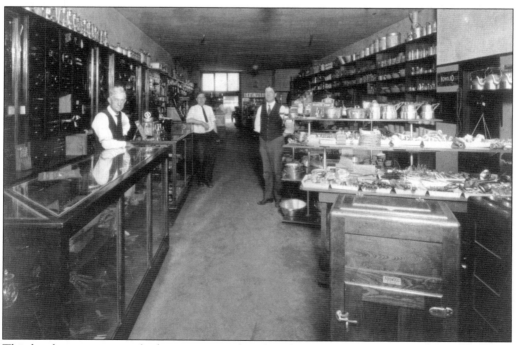

This hardware store supplied customers with oak iceboxes, tin ware, coal pails, and kerosene lamps. (Salida Museum Association)

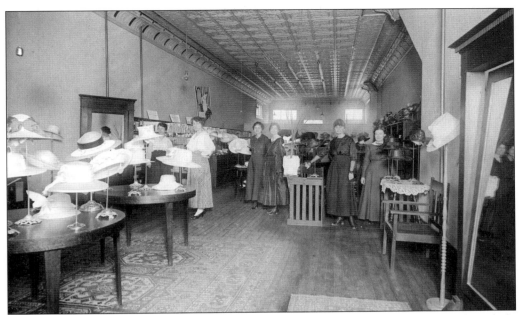

In the early 1900s, service was important. This millinery shop had no less than six clerks to help the woman of the house to find the perfect hat for her social needs. (Salida Museum Association)

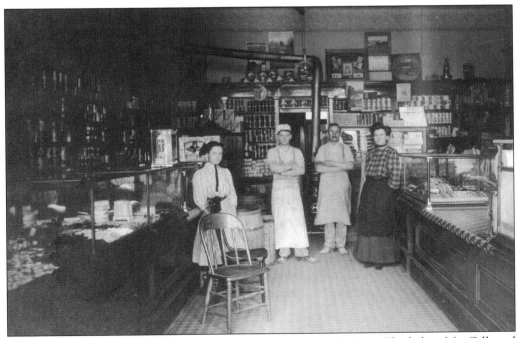

The Enterprise Bakery sold baked goods as well as supplies for baking. The baker, Mr. Gill, and his young assistant were likely at their jobs by three or four o'clock in the morning, getting dough ready for baking. Their work shoes were always covered with flour. (Salida Museum Association)

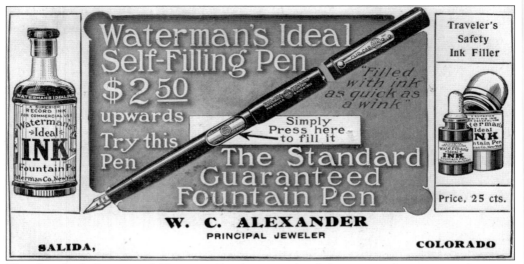

The Standard Guaranteed Fountain Pen was a gift of distinction for an up-and-coming businessman or a lady's correspondence. (Salida Museum Association)

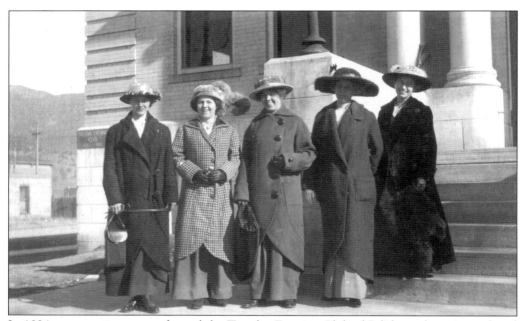

In 1894, community women formed the Tuesday Evening Club of Salida to champion cultural activities, including the establishment of a library. The first year, the group purchased a few books that were kept in various locations, with members serving as librarians and custodians. With some generous donations from individuals, as well as Andrew Carnegie, the Salida Public Library was built at 405 East E Street. These women were pictured c. 1910. The club is still active today. (Salida Museum Association)

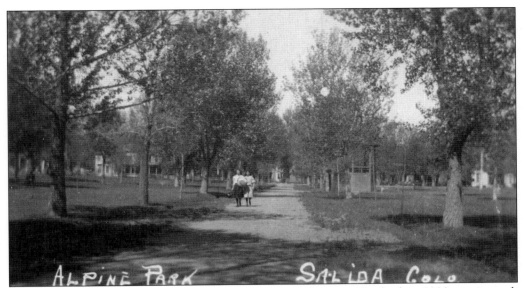

The Alpine Park was planned for early in Salida's development. In the late 1800s, a city park was a social meeting place for crowds or a couple for a private talk. (Salida Museum Association)

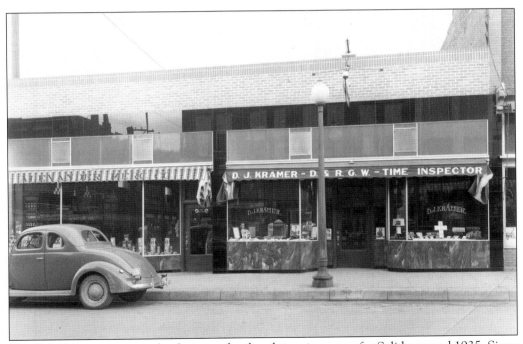

The D.J. Kramer store was the designated railroad time inspector for Salida around 1935. Since the railroad ran on a time schedule, one jewelry store in each town was appointed time inspector to insure the accuracy of all of the train personnel's pocket watches and clocks. (Robert Rush)

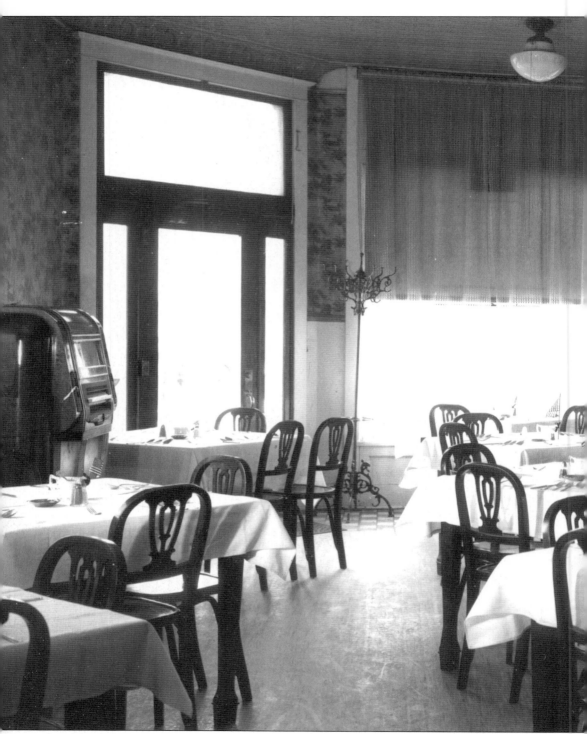

It is March 29, 11:30 a.m., and the tables are set with three spoons, a knife, and a fork. The waitresses are ready for the lunch business at the Sherman Hotel Coffee House. Flags adorn the

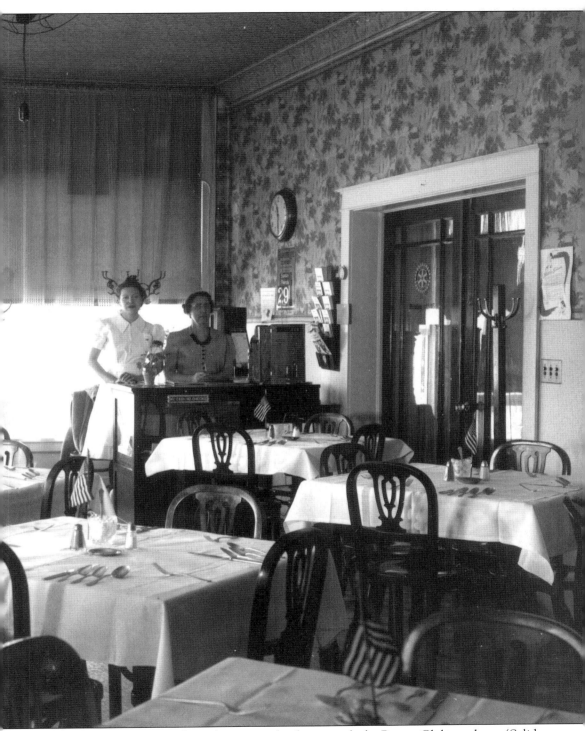

tables, a jukebox stands ready, and a sign on the door reveals the Rotary Club met here. (Salida Museum Association)

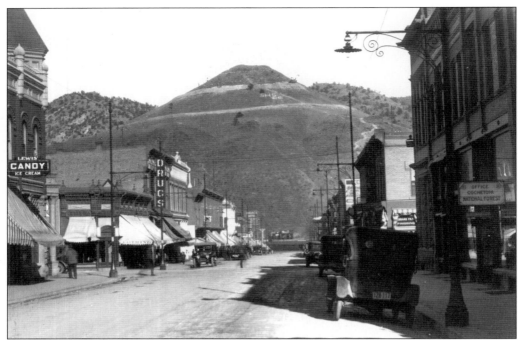

The Lewis Candy and Ice Cream store, Palace Hotel, and the Cochetopa National Forest Office were open for business on Salida's main thoroughfare in 1930. (Salida Museum Association)

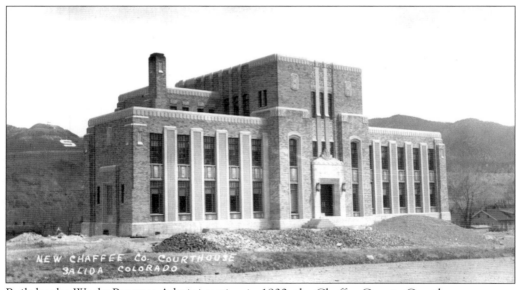

Built by the Works Progress Administration in 1932, the Chaffee County Courthouse was one of countless projects for building or improving public facilities. It is estimated the WPA employed over three million people during the Depression years. (Salida Museum Association)

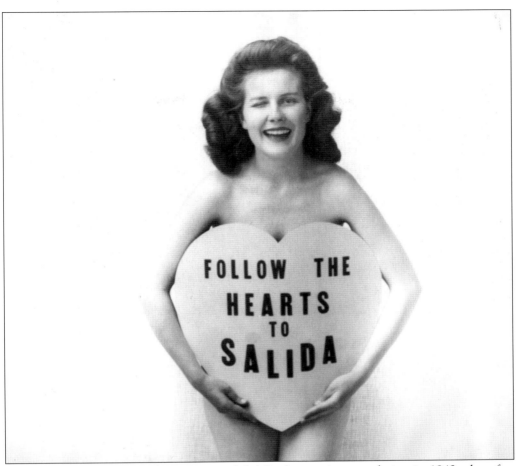

The eye-catching "Follow the Hearts to Salida" ad campaign was daring in 1942 when few women posed nude. A series of photographs like this was a renewed effort to bring more tourism to the area. It seemed to have worked, as it is the major industry today. (Salida Museum Association)

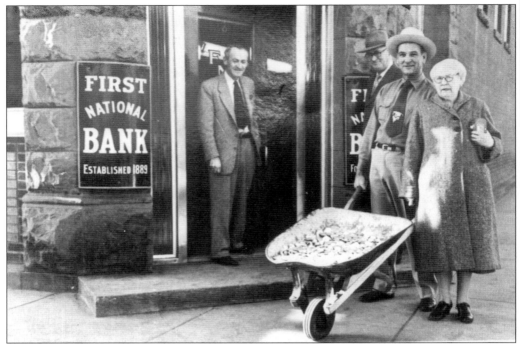

In the 1950s this woman paid off her $3,000 house mortgage in silver dollars. (Salida Regional Library, Alice Chinn)

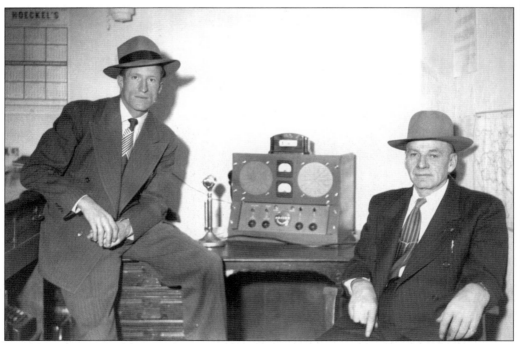

Local law enforcement in the 1940s included an up-to-date radio system for Salida's police department. (Robert Rush)

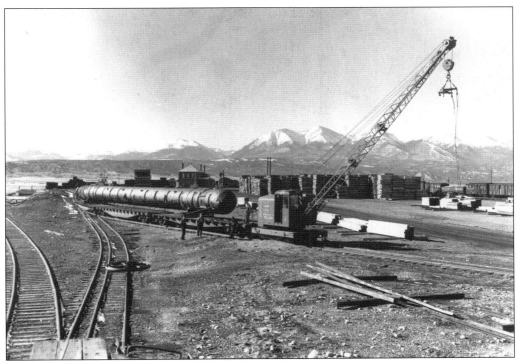

Koppers Creosote Plant employed Salida residents for many years. Creosote was used as a wood preservative for railroad ties, utility poles, etc. (Salida Museum Association)

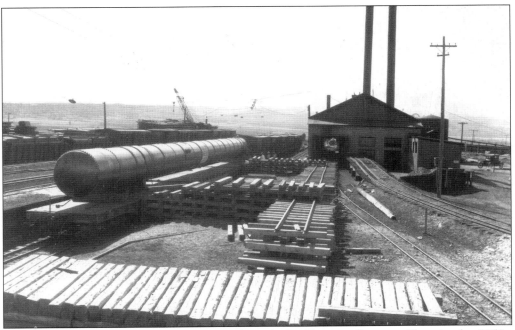

Railroad ties were lined up for processing through the Koppers Creosote Plant in the 1950s. (Salida Museum Association)

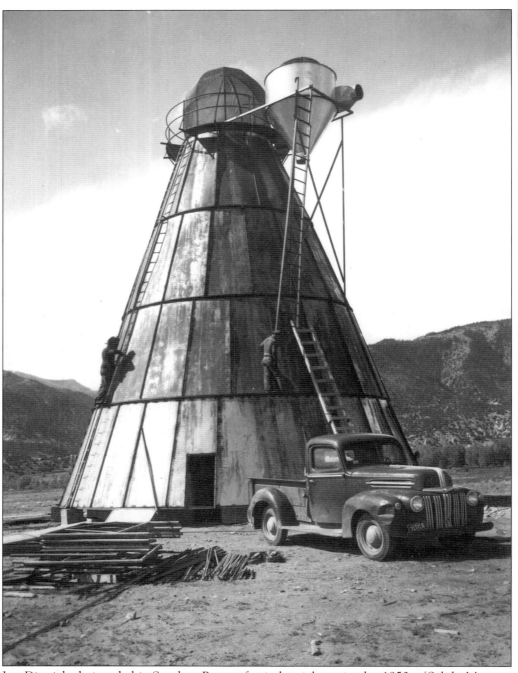

Joe Dietrich designed this Sawdust Burner for industrial use in the 1950s. (Salida Museum Association)

Six

PEOPLE

Many of the people found in these pages are unidentified, their names and circumstances being lost to history. However, the images are connected to Salida and represent times and events that help paint the picture of what life was like in the small western community.

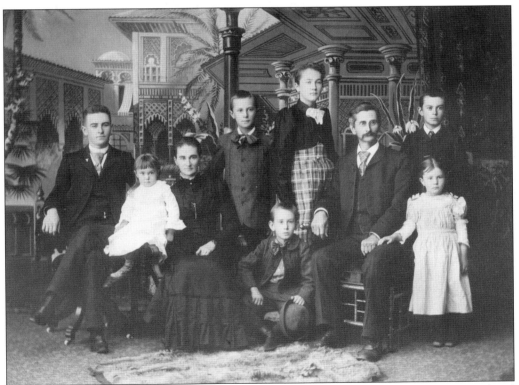

Salida was a destination for many families in the late 1800s after gold had been discovered and the railroads forged into the area. For some reason, this family group was looking off to the side rather than directly at the camera lens. (Salida Museum Association)

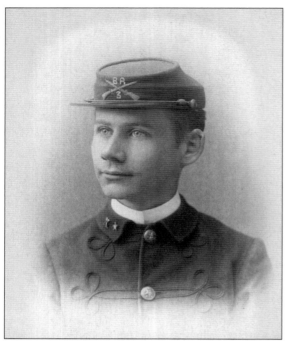

William Alexander served in the Civil War and returned to Salida to establish himself as a pharmacist and businessman. The Alexander name was still associated with business interests in the community nearly 100 years later. (Salida Museum Association)

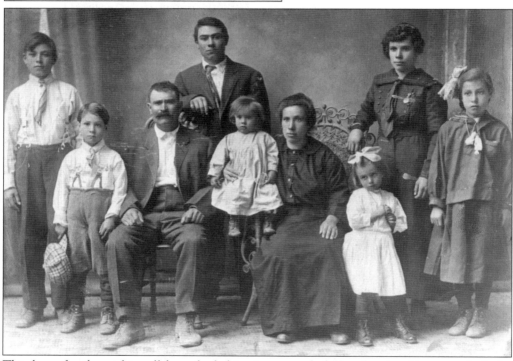

This large family might well have had this picture made before leaving Greece or Italy for America, eventually making their way to Colorado. Immigrants to the area also included Slovaks, Irish, Scottish, German, and Chinese, as well as many other nationalities. (Salida Museum Association)

A.C. Hunt served as Colorado's governor, was influential in establishing Salida as the railroad headquarters for the region, and owned considerable holdings in the area. He was also credited for naming the town. (Salida Museum Association)

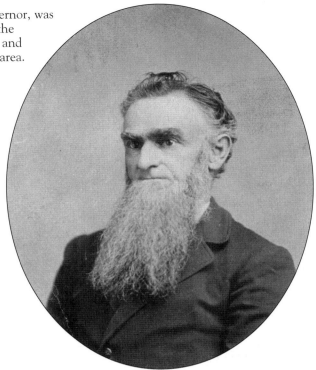

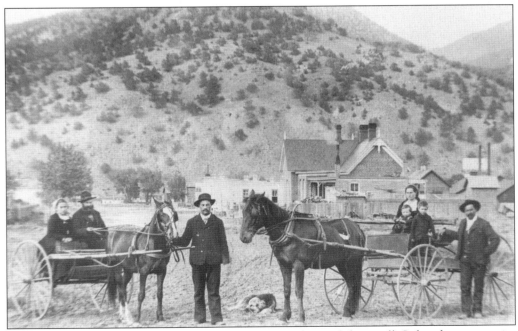

These people posed with their horses and wagons in front of the small Colorado community where they lived around 1900. (Salida Regional Library, Steve Frazee)

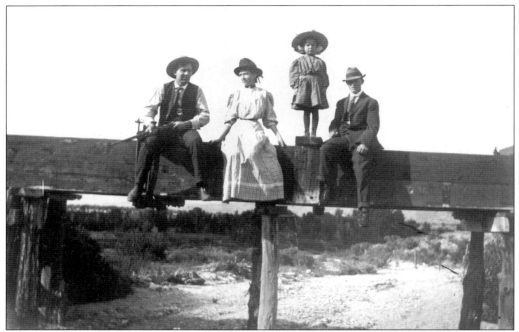

As portraits go, this one was unusual. The family had several poses taken, this one on a dry gulch bridge, about 1900. (Salida Regional Library, Janice Pennington)

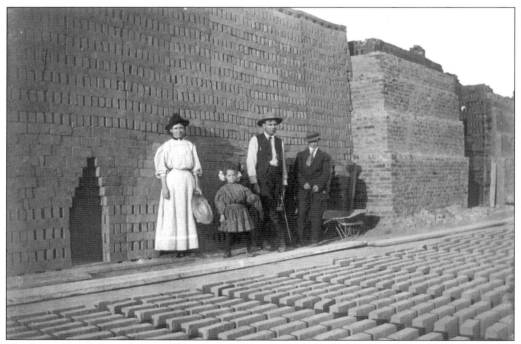

The same family visited the local brickyard where, possibly, one of the men worked. There were numerous brickyards at the end of the 1800s, when fire resistant material was in demand for housing and industrial buildings. (Salida Regional Library, Janice Pennington)

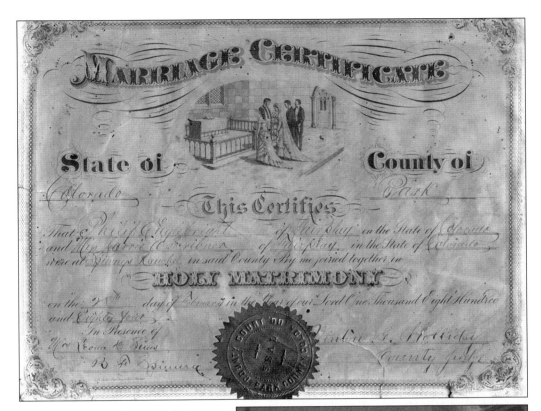

This marriage certificate with the seal of Colorado is dated February 28, 1884. The applicants were from the town of Fairplay. (Salida Museum Association)

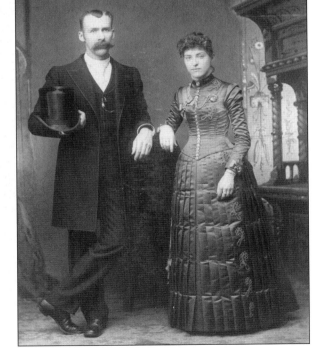

This formal portrait might have been to celebrate the couple's wedding, or some very special occasion with the elaborate dress and top hat, c. 1890. (Salida Museum Association)

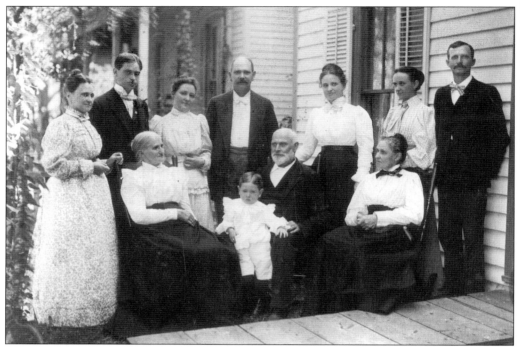

Three generations of the Jones family gathered in front of their house to be photographed, *c.* 1900. (Salida Museum Association)

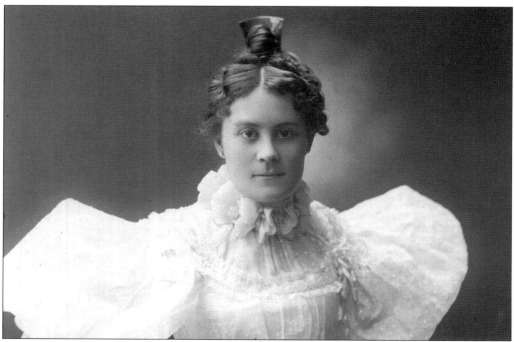

This young woman is high fashion of the 1880s, with her elaborate hair-do and billowing sleeves. (Salida Museum Association)

Cut-outs were fashionable portraiture in the 1930s.
(Salida Museum Association)

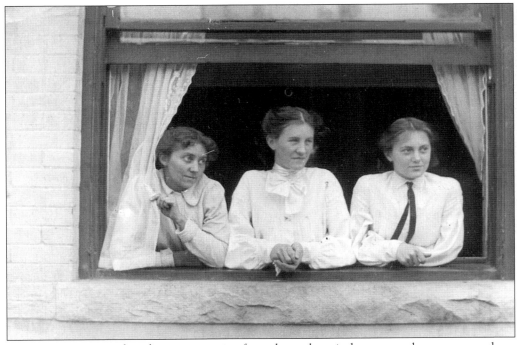

These young women found a vantage point from the parlor window to watch a street parade, *c.*
1910. (Salida Museum Association)

Furs were not only fashionable but a warm wrap for Colorado's bitter winter winds. (Salida Museum Association)

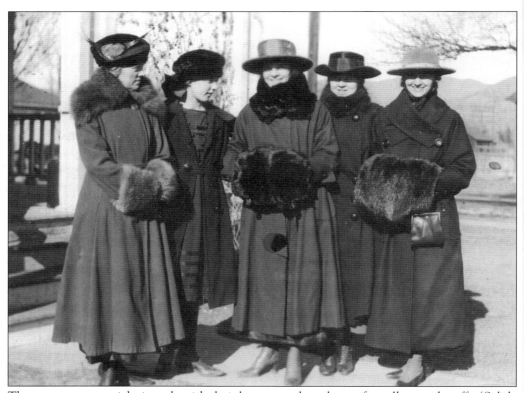

These women were right in style with their long coats, hats, boots, fur collars, and muffs. (Salida Museum Association)

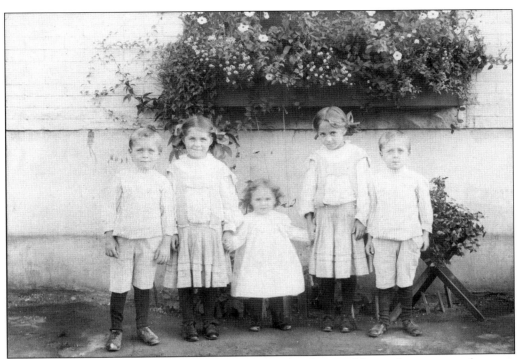

Posed by the family flowerbox, the children have a family resemblance that suggests they may be twins or cousins. The photograph may be a cherished photo from the old country that immigrants carried to Colorado. (Salida Museum Association)

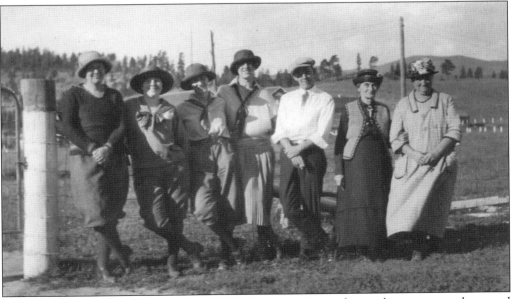

Young women were right with the 1930s times wearing culottes, but most mothers and grandmothers still preferred the "sensible" long skirts. (Salida Museum Association)

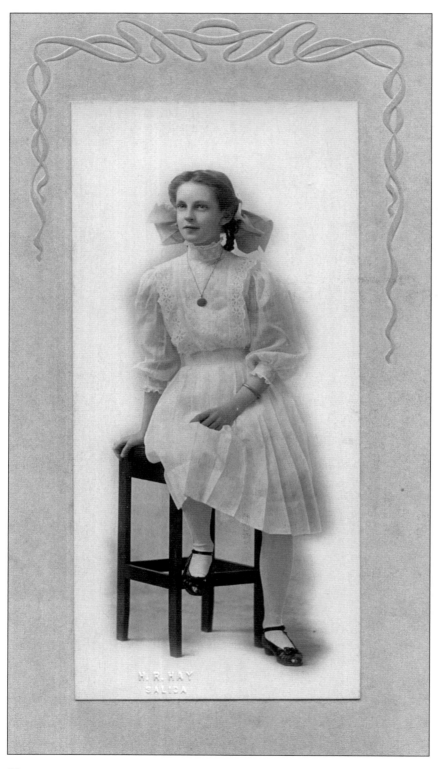

Big bows, a locket, and patent leather shoes were part of the look as this young woman dressed for her portrait at the Hay Studio in Salida. (Salida Museum Association)

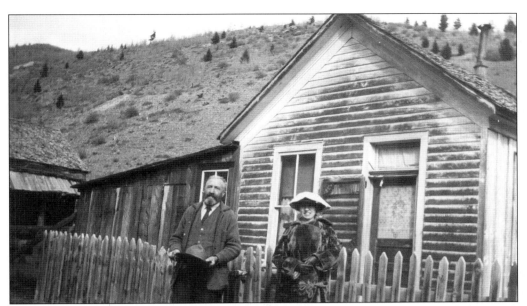

This woman's fur coat looks very prosperous in contrast to this rustic home in the country. (Salida Museum Association)

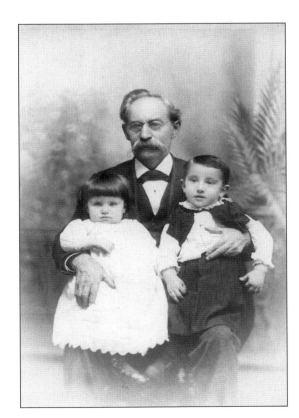

While this appears to be a grandfather with his grandchildren, in a time when many women died at an early age, the children could well be the result of a second marriage. (Salida Museum Association)

These young women seemed to have found Grandmother's hats in the attic. (Salida Museum Association)

This sporty gentleman had his picture made in a new three-piece suit, a jaunty hat, and polished shoes. (Salida Regional Library, Nellie Ellis)

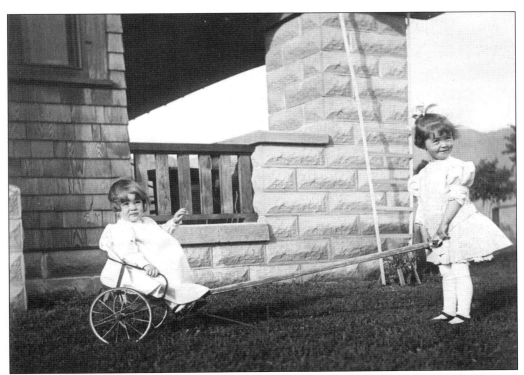

Dressed in their Sunday best, these girls had a wonderful wagon to play with. (Salida Museum Association)

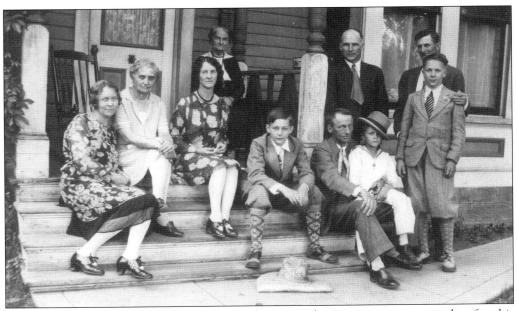

Perhaps it was a quiet Saturday afternoon when several generations came together for this whimsical photo. (Salida Museum Association)

This woman, known as Byrd Fuqua 30 years later, was photographed in Gallatin, Missouri, before establishing a business in Colorado. (Salida Museum Association)

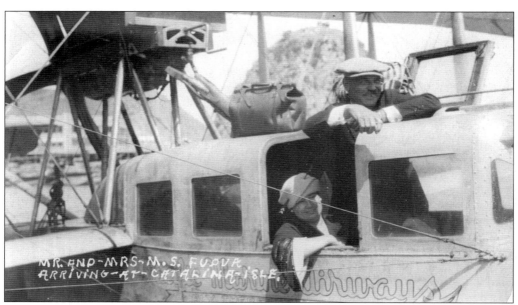

MR. AND MRS. M.S. FUQUA ARRIVING AT CATALINA ISLE

This dude ranch and the Alpine Lodge for boys and girls were only a few of Byrd Fuqua's interests. (Salida Museum Association)

The Alpine Boys Ranch had its share of
colorful characters. Hackimore Ed and
Hot Cake Burt were only two of the crew.
(Salida Museum Association)

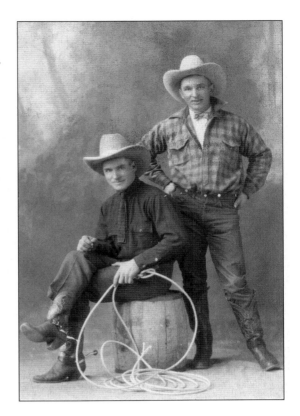

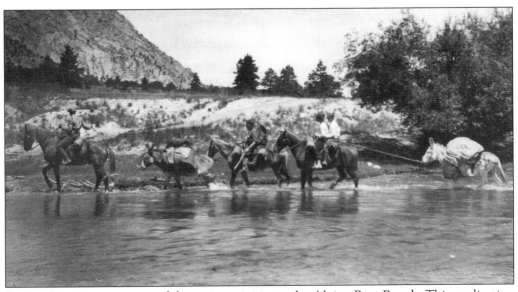

Backpacking trips were one of the main activities at the Alpine Boys Ranch. This application
from the ranch shows parents paid $600 for children to spend the summer. (Salida Museum
Association)

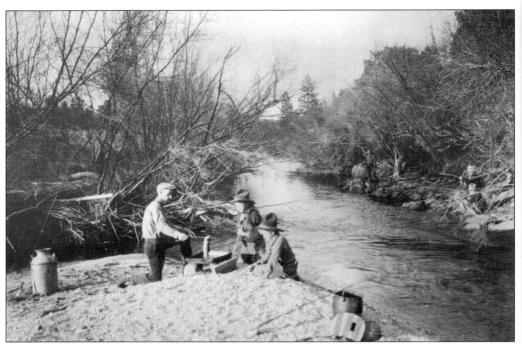

Catching fish meant eating dinner beside a cool running stream in the Colorado mountains for these young boys. (Salida Museum Association)

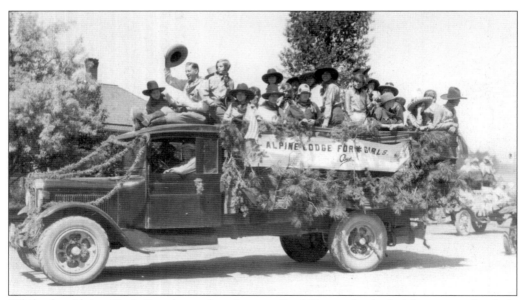

While the Alpine Boy's Ranch was best known, Byrd Fuqua also had girl guests and a dude ranch. (Salida Museum Association)

Helen Hanks' father bought a photographer's studio in Salida. The young woman followed in his footsteps and became a photographer, recording family, friends, and clients with skill and sensitivity. (Salida Museum Association)

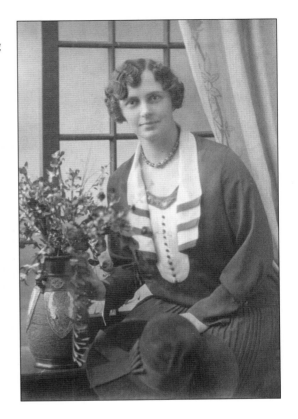

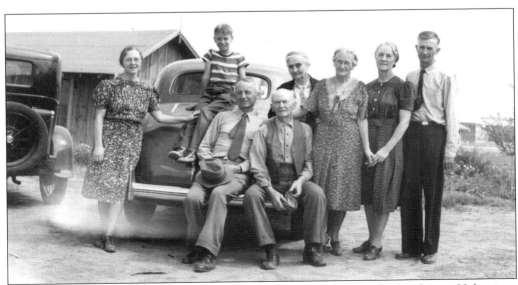

Members of the Hanks family gathered for an informal portrait on the family car. Helen is at the far left, c. 1930. (Salida Museum Association)

Helen Hanks' photography included many photographs of local women. This one seems to be the height of 1930s fashion with her cloche hat, bead bag, and fur collar. (Salida Museum Association)

Women often donned costumes for theatrical events to raise money for special causes. However, few had a fine portrait made to commemorate the event. (Salida Museum Association)

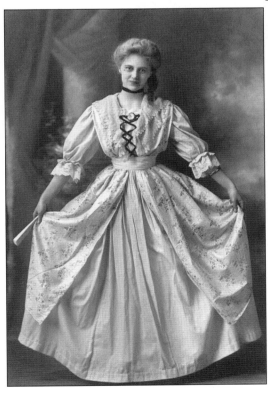

This elaborate period frock could have been for a play or a costume ball. (Salida Museum Association)

Salida had many photo studios over the years. Erdlen made this cabinet card image around 1890 for the gentleman to present to a special friend or family member. (Salida Museum Association)

Used to produce these unusual photographs, a cirkut camera pictured linear groups for school girls, women's organization, working people, etc. (Salida Museum Association)

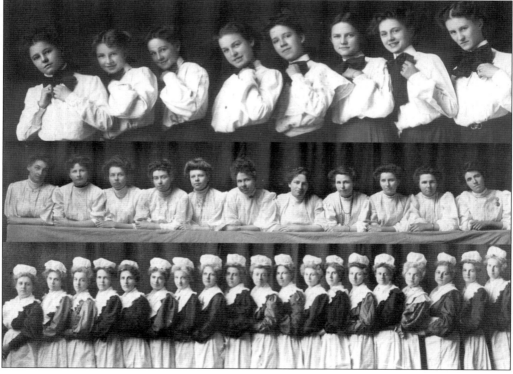

Seven
RECREATION

*F*un is part of the human experience. Fortunately, many photographers chose to record that fun on film, leaving us in the 21st century with a glimpse of some leisure activities the people enjoyed. Some of those activities were formally organized, like the bands, parades, and the girls' basketball teams, but more were spur of the moment: "lets take a drive, go for a walk in the park, or ice skate."

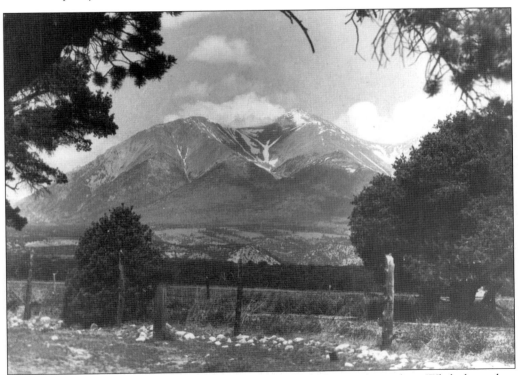

The mountains were recreation and beauty, and they held special wonders. While legendary Indian maiden the Angel of Shaveno has been recognized since early times, some more recent observers report they can also see the Grinch just to the left in the photograph. (Salida Ranger District, San Isabel National Forest)

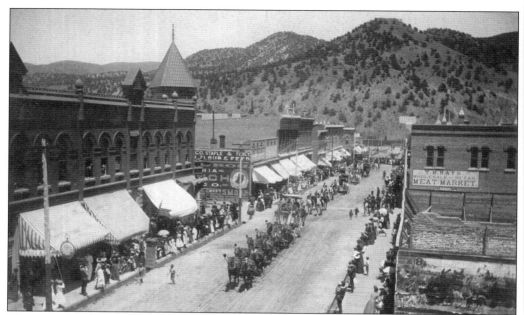

The circus was high entertainment in the days before radio and cars. In the early 1880s, the first circus pulled into town on the railroad, the tents were raised, and then the parade began. Most of the town turned out and bought a ticket to see the spectacle. The support continued as this 1894 photo verifies. (Salida Museum Association)

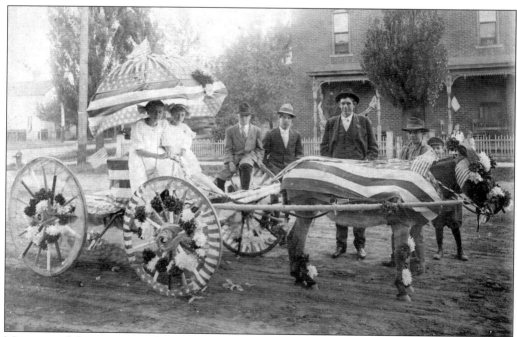

Most special dates warranted a parade and this one might have been for the Fourth of July. The streets are now paved, a new century has begun, and Salida parades are still very well attended. (Salida Museum Association)

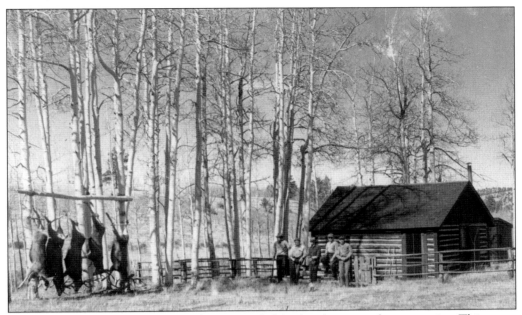

Deer, elk, antelope, and mountain sheep provided food and sport in the mountains. This group found lots of both for their efforts in 1954. (Salida Ranger District, San Isabel National Forest)

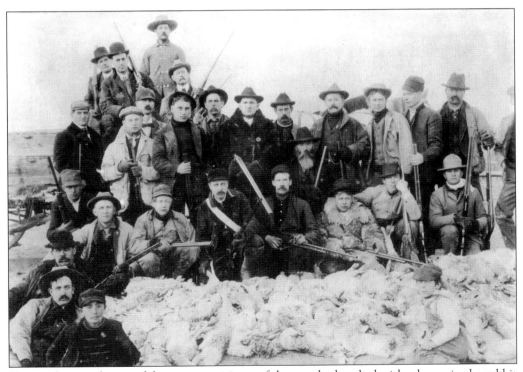

Having destroyed most of the coyotes, citizens of the area had to deal with a boom in the rabbit population. Special hunts were organized to diminish the numbers around 1900. (Salida Museum Association)

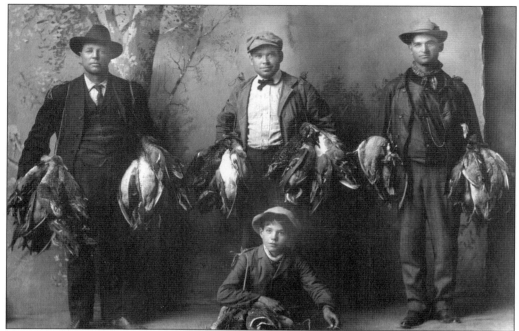

Rich in game, the area supported local hunters who had to feed their families, as well as the tourist sportsmen who had a studio photograph made of their adventure. (Robert Rush)

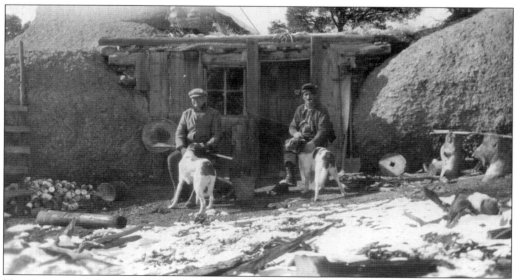

Hunting camps have probably become more comfortable since the early 1900s but the combination of a man, his gun, and his dog will always be the same. (Salida Museum Association)

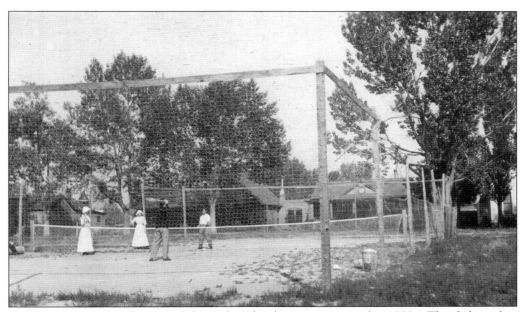

Tennis was introduced as a Salida High School team sport in the 1920s. The fashion has changed considerably since that time. (Salida Museum Association)

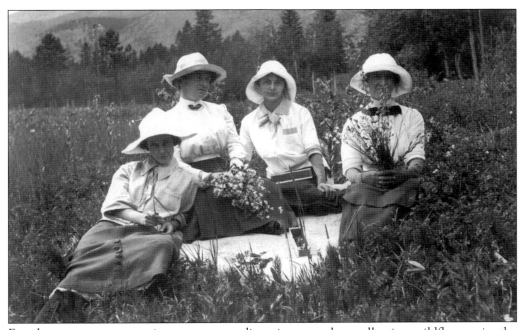

For these women, recreation meant spending time together collecting wildflowers in the mountains around their home. (Salida Museum Association)

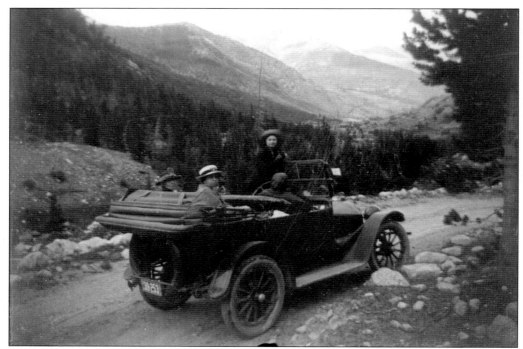

Ever since the advent of the automobile, a drive in the country has meant a good time if you were able to avoid flat tires, rock slides, or running off the rough roads. (Salida Regional Library)

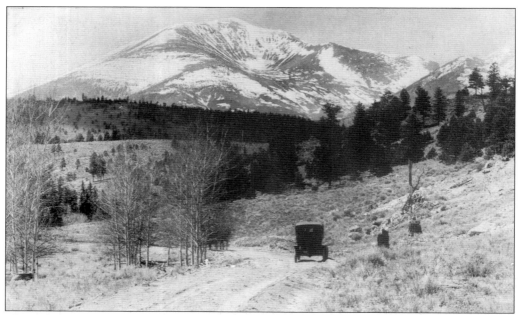

The 1920s brought the automobile and it was fast overtaking the horse and buggy as preferred transportation. This one is giving the oncoming carriage a wide berth. (Salida Ranger District, San Isabel National Forest)

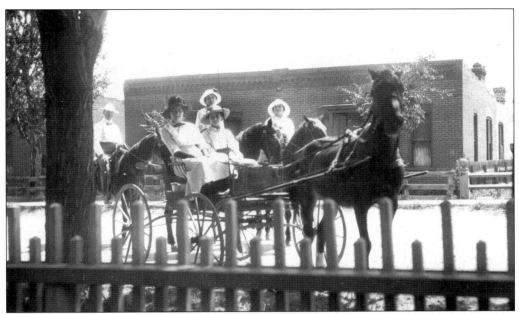

Even after cars were widely available, many families kept a horse and carriage for outings. (Salida Museum Association)

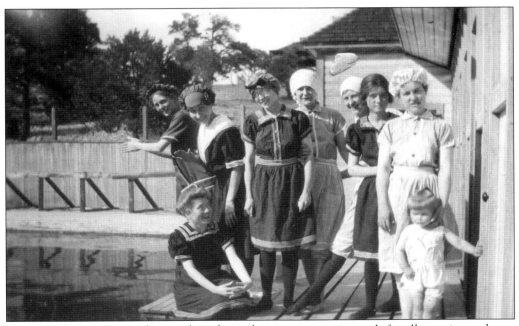

Numerous hot springs in the area lent themselves to community pools for all to enjoy and cure their ills. (Salida Museum Association)

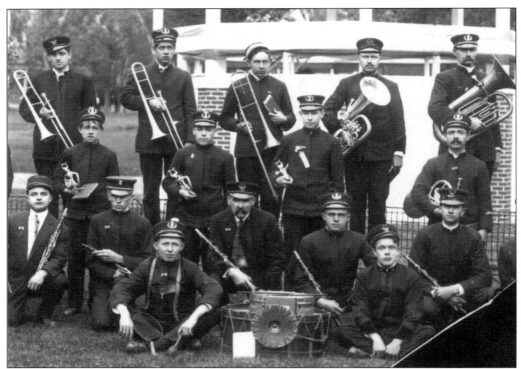

Brass bands were very popular around the turn of the century, and many organizations and industries formed their own. The Salida Men's Band performed for many community functions. (Salida Museum Association)

Looking smart was part of an organization's showmanship. This 1884 invoice is for the Iron Mountain Lodge #19: a tunic was $9 and sandals $2.25. (Salida Museum Association)

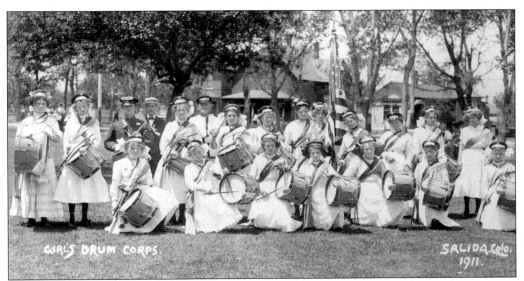

The Salida Girl's Drum Corps of 1911 is pictured in Alpine Park, where they performed for special events. (Salida Museum Association)

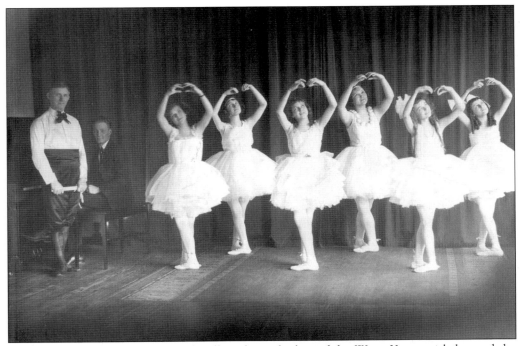

Dance and the arts were alive and well in the early days of the West. Young girls learned the finer points of ballet with the help of the dance master and the pianist (Salida Museum Association)

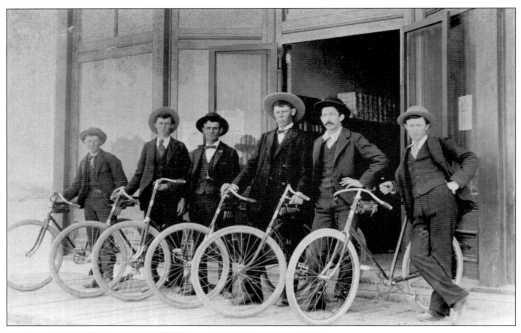

These young men had the very latest in two-wheel transportation. They might be young salesmen, proud owners, or telegram delivery boys. (Salida Regional Library, M. McClure)

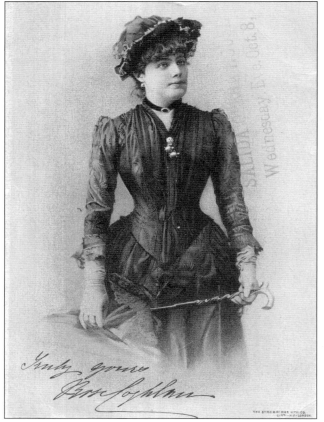

The Opera House hosted dozens of entertainers. This imposing lady appeared around 1890 and autographed a picture of herself for an admiring fan. (Salida Museum Association)

The Salida Opera House program of 1906 sported advertising. Ramsay Dry Goods promised a NEW PAIR of shoes without the least hesitation should they not provide absolute satisfaction. (Salida Museum Association)

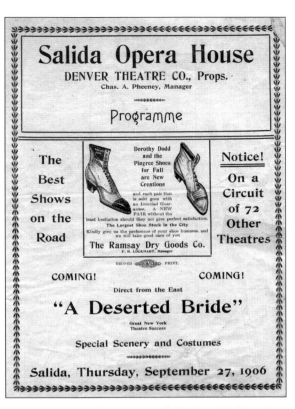

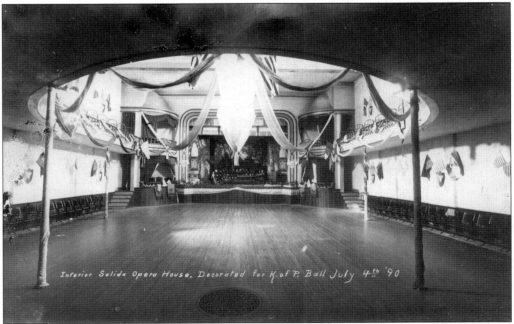

The Opera House hosted a variety of entertainment for the community. On July 4, 1890, it was decorated for the Knights of Pythis Ball. (Salida Museum Association)

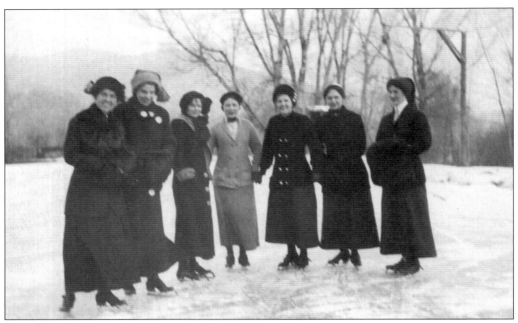

Coats flapping in the wind, these hardy skaters are enjoying themselves on a blustery Colorado day. (Salida Museum Association)

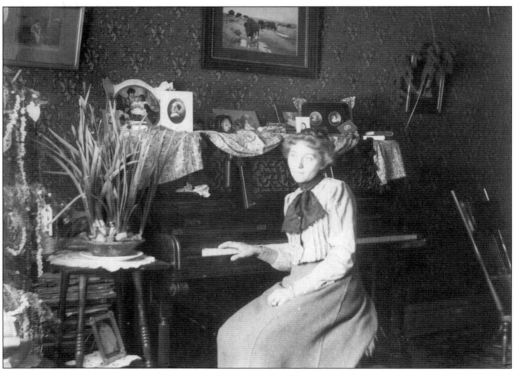

Homemade music was great entertainment for some of the early residents of Salida and a piano was a fixture in many houses. (Salida Museum Association)

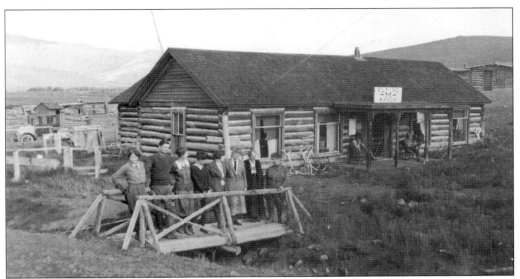

The Flying M Ranch was a vacation getaway for this group. (Salida Museum Association)

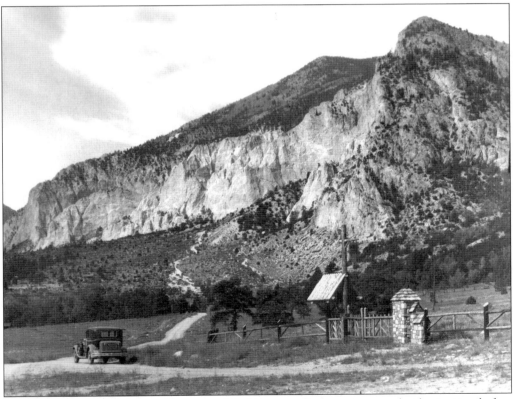

Fifteen miles from Salida, a golf course at Mt. Princeton Resort was a popular destination before the 1930s. The Depression struck a blow from which the facility never recovered. The resort's buildings were razed in the 1950s. (Salida Museum Association)

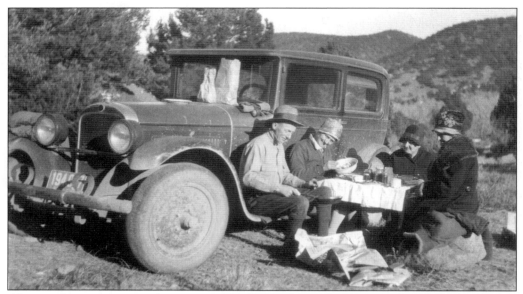

Always a favorite pastime, this picnic took place at the roadside on a rather chilly day. (Salida Museum Association)

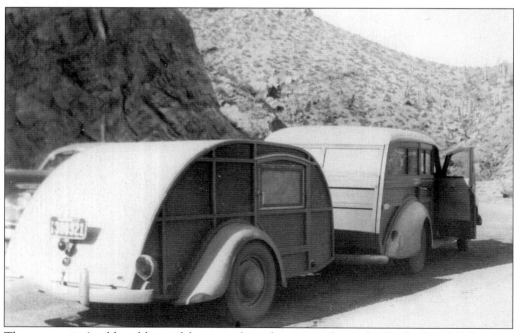

The mountains' wild and beautiful scenery brought visitors from afar. In the late 1930s, some brought their house with them and stayed for weeks. (Salida Museum Association)

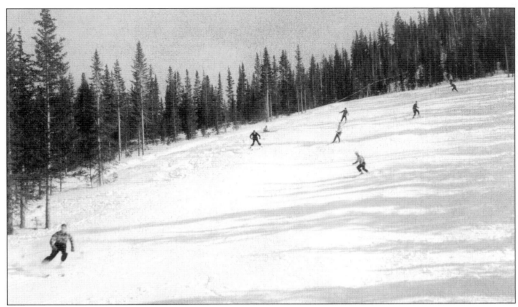

Prepared ski hills were still not so crowded in the 1940s. It would be hard to find this much room on the slopes today. (Salida Ranger District, San Isabel National Forest)

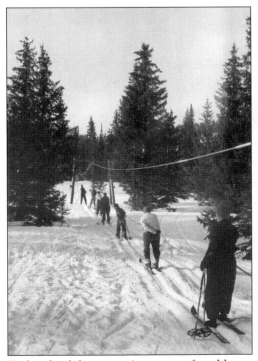

Early ski lifts weren't as comfortable as modern models, but they got the skiers up the mountain just the same. (Salida Ranger District, San Isabel National Forest)

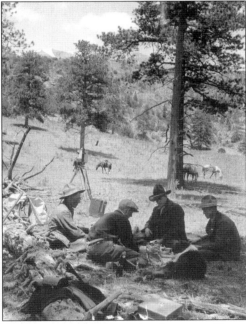

These men went into the forest to film a segment before 1920. In the days before television, many of these kinds of films were used in the newsreels before showing feature movies. (Salida Ranger District, San Isabel National Forest)

123

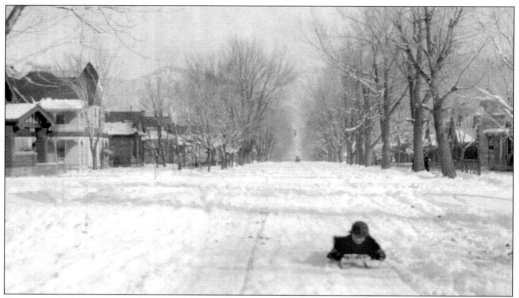

Snow might mean trouble for automobile drivers and homeowners, but to a child, it was just fun. While winters in Salida are often mild, recently a 50-inch snowfall was recorded in May. (Salida Museum Association)

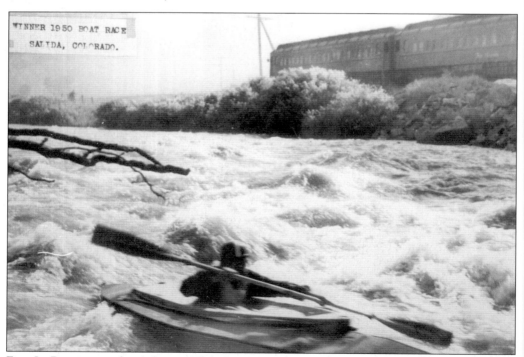

First In Boating on the Arkansas Klub (note German spelling) started racing on the river in 1949, the first event being 56 miles. It took early participants to the Royal Gorge, but in the third year, the race was shortened to finish at Cotopaxi Bridge. In the early years of the race, a spectator train followed the action and kept observers high and dry in comfort. (FIBArk)

The 26-mile race held annually in mid-June offers whitewater challenges from class two through four for canoes and kayaks, and draws participants from many states and foreign countries. (FIBArk)

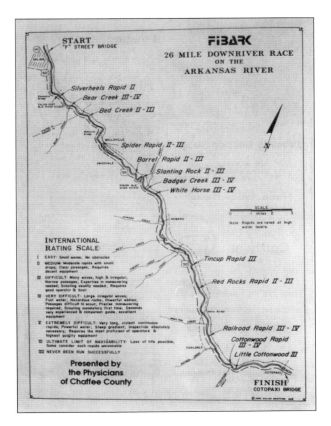

FIBARK

26 MILE DOWNRIVER RACE
ON THE
ARKANSAS RIVER

START
"F" STREET BRIDGE

Silverheels Rapid II
Bear Creek III - IV
Bed Creek II - III
Spider Rapid II - III
Barrel Rapid II - III
Slanting Rock II - III
Badger Creek III - IV
White Horse III - IV

Tincup Rapid III
Red Rocks Rapid II - III
Railroad Rapid III - IV
Cottonwood Rapid III - IV
Little Cottonwood III

FINISH
COTOPAXI BRIDGE

INTERNATIONAL
RATING SCALE:

I EASY: Small waves, No obstacles
II MEDIUM: Moderate rapids with small drops, Clear passages, Requires decent equipment
III DIFFICULT: Many waves, high & irregular, Narrow passages, Expertise in maneuvering needed, Scouting usually needed, Requires good operator & boat
IV VERY DIFFICULT: Large irregular waves, Fast water, Hazardous rocks, Powerful eddies, Passages difficult to scout, Precise maneuvering required, Scouting mandatory first time, Demands very experienced & competent guide, excellent equipment
V EXTREMELY DIFFICULT: Very long, violent continuous rapids, Powerful water, Steep gradient, Inspection absolutely necessary, Requires the most proficient of operators & highest quality equipment
VI ULTIMATE LIMIT OF NAVIGABILITY: Loss of life possible, Some consider such rapids unrunnable
VII NEVER BEEN RUN SUCCESSFULLY

Presented by
the Physicians
of Chaffee County

SCALE
miles

Note: Rapids are rated at high water levels.

Locals and visitors alike took part in hiking the mountain hills and enjoying the snow melt waterways. (Salida Museum Association)

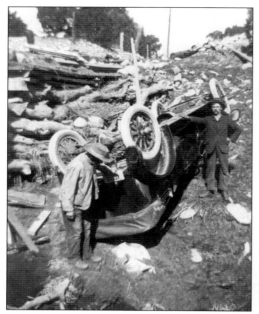

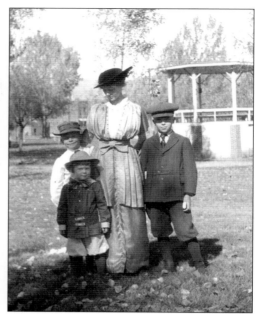

Driving was a hazardous pastime and many an automobile found disaster around the next curve. (Salida Regional Library, Josephine Soukup)

Alpine Park was a popular place for the family in 1900. Today the park is still a gathering place for visitors and residents of Salida. (Salida Museum Association)

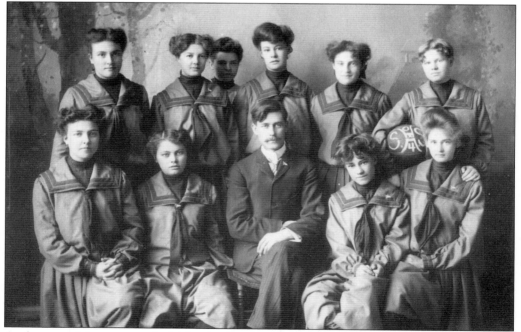

At the turn of the century, the high school had football, basketball, and track teams for the boys but round ball was the only team sport open to girls. This is the 1904 Salida High School Girl's Basketball Team. (Salida Museum Association)

Index